W9-BLI-150

FL-488

U UNIVERSAL

Uamta

TITANIC
ATE WINSLET

Photographs and films were illegal under the Taliban. Since their defeat in 2001 shops in Kabul abound with images of movie stars like *Titanic's* Kate Winslet, who remains a popular model for women despite the lapse of four years since the film's release.

7/02

UN|VEILED

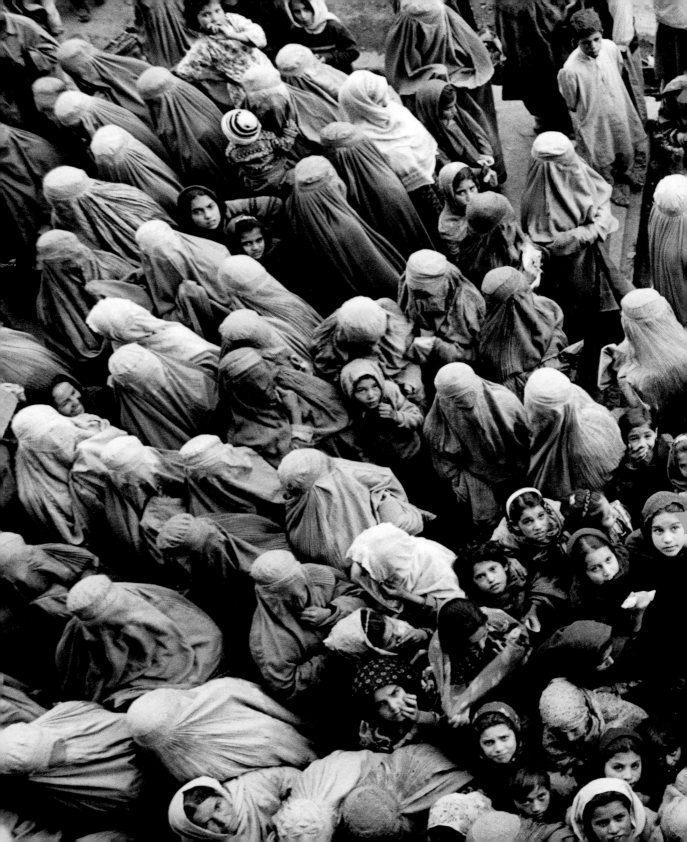

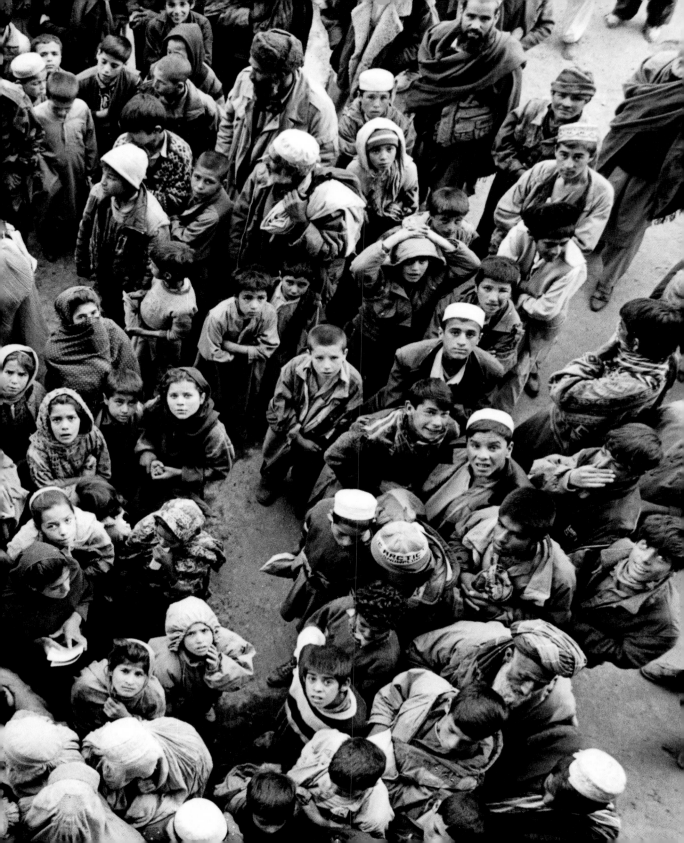

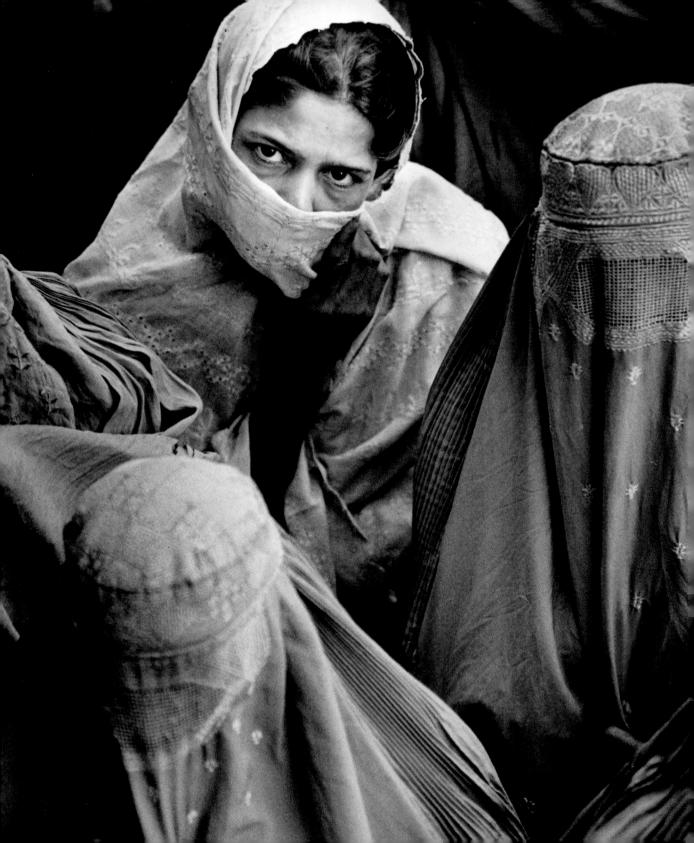

VOICES OF WOMEN IN AFGHANISTAN

UN|VEILED

HARRIET LOGAN

ReganBooks
An Imprint of HarperCollinsPublishers

FIRST EDITION
DESIGNED BY BAU-DA DESIGN LAB
PRINTED ON ACID-FREE PAPER
LIBRARY OF CONGRESS CATALOGING-IN-PUBLICATION DATA
HAS BEEN APPLIED FOR.
ISBN 0-06-051087-0
02 03 04 05 06 ❖/PHX 10 9 8 7 6 5 4 3 2 1

THIS BOOK IS FOR
MY CHILDREN, JACKSON AND FREDDIE,

AND FOR MY HUSBAND, ANDY.
WITHOUT YOUR LOVE AND SUPPORT,
I WOULD NEVER HAVE GONE BACK TO AFGHANISTAN.

AND FOR THE WOMEN OF AFGHANISTAN:
MAY YOU ALL FINALLY LIVE IN A COUNTRY THAT RESPECTS YOU
AND GIVES YOU THAT TO WHICH YOU ARE ENTITLED.

CONTENTS

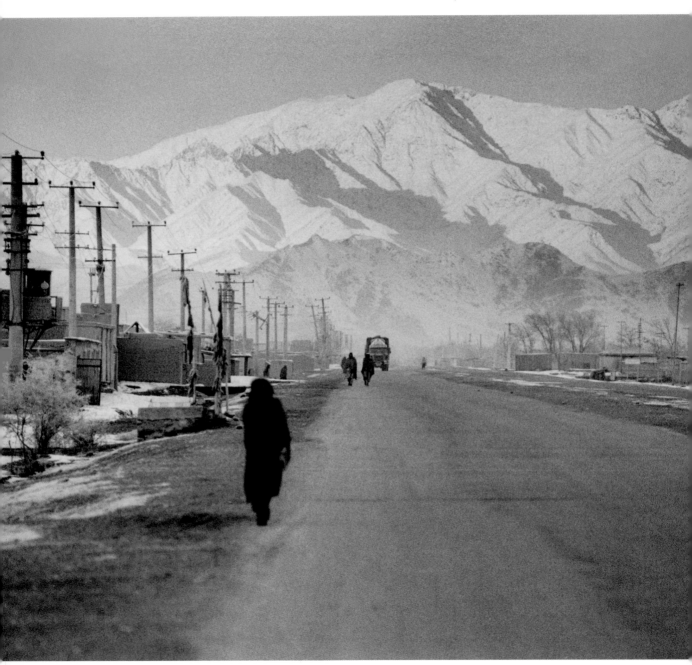

The road into Kabul

INTRO|DUCTION

IN DECEMBER 1997, the *London Sunday Times Magazine* asked me to go to Afghanistan. Fifteen months before, the Taliban had taken control of the country after three bloody years of fighting against the mujahideen. This latest struggle added another chapter to Afghanistan's long history of wars.

I had always wanted to visit Afghanistan. I couldn't imagine a country with a more fascinating history or uncompromising present, and I dropped everything to take the assignment.

The *Sunday Times* writer and I flew to Peshawar, near Pakistan's northwestern frontier, and spent one night there on the way to Afghanistan. We shopped in the hectic bazaars for *shalwar kameez* (the long shirt and baggy pants worn by Afghan and Pakistani men and women) and a few rations—in anticipation of the provisions we would find inside Kabul. Early in the

morning, we collected our Khyber Pass guard from the Ministry of the Interior. He was an elderly man who sat in the front of our taxi clutching his ancient rifle. I wondered how well he would be able to defend us if anything happened!

We crossed the city's borders, passing through the famous smugglers' market where one can buy any kind of weapon imaginable, from a Kalashnikov to a tank. We entered the Khyber Pass, where misshapen crossed guns with the words KHYBER PASS RIFLES WELCOME YOU were cut in chalk and rock in the hills above us. Torkham, the border crossing between Pakistan and Afghanistan, was frantic with trucks and cars and people moving between the two countries. Faces and hands pressed at our car's windows, causing us to feel like goldfish in a glass bowl as the children around the car begged for food.

Our passports and permits were scrutinized in the immigration office and copied into an ancient ledger. We exchanged our Pakistani taxi for an Afghan one and crossed through the barbed-wire fence which marks the Afghan border. All along the road, the white flags of the Taliban were flying, strung up and fluttering—some small as napkins on the tops of buildings by the road, others high up in the hills above us.

Our driver grinned as he showed us the hidden cassettes in his car, and shook his head at the absurdity of the Taliban's regulations. Each time we neared a checkpoint, he made sure that my head was sufficiently covered and that we were not doing anything that might bring any more attention from the Taliban than we were already likely to cause as Westerners. (Later in the trip, my driver and translator were beaten once because my veil had pulled back and shown a small amount of hair when I got out of our car.)

We dozed in the back of the car as we crossed the plains on the outskirts of Jalalabad. Although that day was bitterly cold, Afghans often refer to the area as "tropical," and, indeed, the summer brings enough heat to grow the tangerines, oranges, and pomegranates which were displayed in the small stalls along the road. And here too grow the opium poppies, despite what the Taliban told the United Nations and the United States.

At one point in our journey, the road petered out and was replaced by a dusty pitted track scarred by years of fighting and the wear of tanks. The dust, fine and powdery as talc, became unbearable. Our eyelashes became encrusted with it, and it seemed to permeate everything; I worried for the safety of my cameras as the bag they were in collected a thick coating of it.

We passed through checkpoint after checkpoint of fasting Taliban (it was the holy month of Ramadan), all of whom peered into the car and nudged each other at the rare sight of Westerners. Although the trip was less than a hundred miles, it took us nearly six hours to reach Kabul, and it was getting dark by the time we arrived.

We were the only two guests at the Intercontinental Hotel, with its cavernous and empty corridors, many of which had no outside walls because they had been destroyed in bombardments. The hotel was freezing and all of its electric radiators were placed in our rooms to keep us warm. The next morning, we registered ourselves at the Ministry of Internal Affairs. Because photographing people was illegal under the Taliban, I told them that I was there to photograph "war damage." Amazingly, they seemed to believe me, but they did provide us with a Taliban driver and interpreter in order to keep a close eye on what we were doing. For six days, the two would appear dutifully each morning in the hotel reception area only to be given the runaround by my writer so I could visit women undetected.

I found the women I interviewed and photographed in 1997 and 2001 thanks to Physiotherapy and Rehabilitation Support for Afghanistan (PARSA), a small nongovernmental organization run by Mary MacMakin, a spirited, elderly American woman with over forty years of experience in Afghanistan. Many of the women refer to Mary in their interviews—they see her as a mentor, an employer, a friend, and a champion for their rights. With a small amount of funding and incredible dedication, PARSA has worked in Afghanistan since 1996 to help improve people's lives. It supports a variety of projects, including home schools, wool and weaving programs, and training and education for war widows. PARSA operates on an

itimate, grassroots basis with its beneficiaries, and in this way, it has maintained an awesome network of women. The women PARSA introduced me to were extremely brave to talk to a Westerner at that time.

According to a Taliban decree enforced by the religious police, it was illegal for a woman to ride in a car with me, or even to talk to me. The risk they took in having their picture taken was especially grave, since the Taliban considered photography to be a form of idolatry. But the women were willing to take these risks because they felt that it was imperative for the outside world to know what was happening to them. Over and over, they told me, "We have been forgotten, and we need the right to speak. If no one hears what we say, nothing will change."

Working with my translator, Marina, I was virtually smuggled into women's homes, where I was always met with immeasurable warmth and kindness. We had to be constantly vigilant about who saw us enter these houses so that we were not reported. Often the women asked me to wear a burkha when traveling between their homes, and they lent me their shoes so that no one noticed that my own were not typically Afghan.

The city was deep in snow and as I climbed the steep hill that leads up to Shafika's house, she and Marina had to support me because walking in a burkha was so difficult, especially with my cameras hidden beneath it.

It is customary for Afghan women to kiss each other on the cheeks as a greeting. When I entered their homes and pulled my burkha back, the women would hold my face in both hands and kiss me over and over again, laughing as they did so at the sight of my "men's clothes." It must have been strange for them to have a Western woman in their homes at all. Even though it was Ramadan, they insisted on making me green tea in huge decorated thermoses and refilled my cup the second I finished it. They also brought me bowls filled with tiny gold-wrapped toffee sweets, sugared almonds, green sultanas, or hard crunchy chickpeas.

Almost as soon as I entered Zargoona's tiny, freezing room, she started to cry. She, Marina, and I huddled together under thick, heavy blankets. Tears ran down Marina's face as she translated Zargoona's strangled voice. Her story was heart-wrenching.

When I photographed on the street, I was unable to raise my camera to my face, so I had to take all the pictures without looking. We only realized the tension we had been under when we left Kabul—a city ruled by fear. The effect on its population was physical.

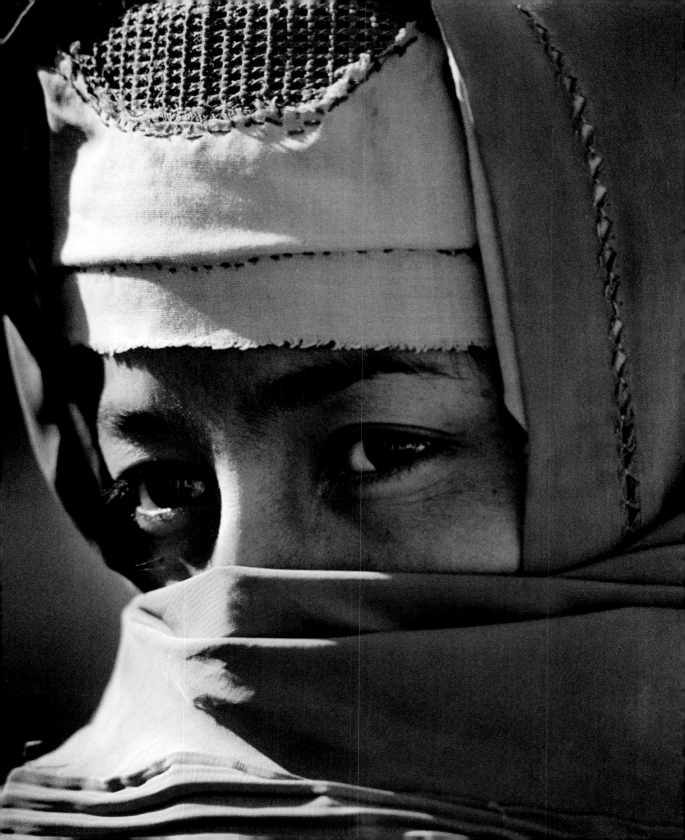

FOUR YEARS AND TWO CHILDREN LATER, I returned to Peshawar and started the daunting process of trying to enter Afghanistan.

Mary MacMakin was living in Peshawar because she had been expelled from Afghanistan for criticizing the Taliban in her newsletters. It was a joy to see Mary again, and she gave me the number of Palwasha's brother, Fahrid, to help me refind the women of Kabul I had met on my first trip.

Entering Afghanistan was a trying process. My traveling companions (two other photographers) and I spent a week hiring and firing a host of different Afghan and Pakistani guides who guaranteed us increasingly bizarre methods of entering Afghanistan. At one point, we thought that our only access was by horseback through a remote and snowy mountain pass. Three days before our arrival, four journalists had been brutally murdered on the road from Jalalabad to Kabul. It was no surprise that everyone told us that following that road would be suicidal. The United Nations was offering flights from Islamabad into Kabul for a "mere" twenty-five hundred dollars one way, and even at these rates, the waiting list was long!

After having been turned away once at the border, we were told that the family of the deceased warlord Abdul Haq offered armed escort for journalists from Peshawar to Jalalabad. Once there, we had the prospect of the extremely dangerous travel on to Kabul, and there were few safe options. Our savior came in the form of the mayor of Jalalabad, Engineer Abdul Ghaffar, who had been asked to visit Interim President Rabbani in Kabul to discuss the situation. Ghaffar had organized a seven-car convoy for the journey with thirty-seven armed escorts, and he offered to take any journalist with him.

Two days later, we started the nerve-racking drive to Kabul. At one point, the armed men in the pickup truck in front of us stopped and got out. "They have seen some people in the hills above us," Ghaffar told me, as the driver squinted up the sides of the steep ravine we were in. I shrugged down inside my bulletproof jacket and closed my eyes.

Night fell as we entered Kabul and went to the Intercontinental Hotel, which was overrun by journalists. Unable to offer us a room, they recommended another hotel to us. Unperturbed by the fetid state of the place, we felt lucky to have a room for the ten days we spent there. In the morning, I hired a driver and searched out a young female translator who had been recommended to me. Fahrid, Palwasha's brother, completed my team as my guide, to help me track down the women I had met in 1997.

It was remarkable how much the city had changed in the few weeks since the Taliban's departure. Objects banned under Taliban rule had reemerged everywhere. The bazaars were

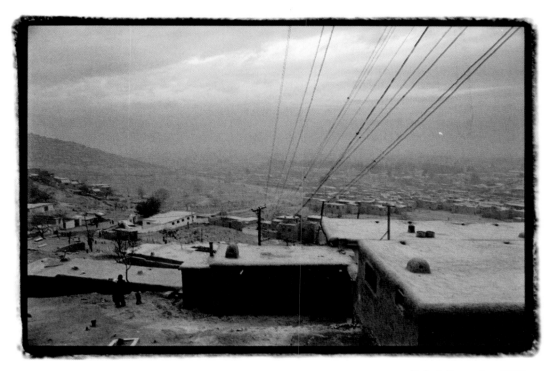

Kabul, December 2001

packed with televisions, video recorders, and cassette tapes. Every second shop seemed to be wallpapered with posters and postcards of Indian singers and (strangely enough) Kate Winslet, who seemed to be in huge demand after the great, though underground, success of *Titanic* in Afghanistan. The sky was decorated with hundreds of kites, many made simply from plastic bags adorned with pictures of Rambo. There were mannequins in the shop windows, and makeup, and white shoes on sale on the street, and women's underwear hanging in the markets, and packaging with female faces on it. In some parts of the city, the streets were lined with rows of vivid satellite dishes made from colorful tin cans. Hundreds of pigeons were on sale at the end of Chicken Street, and photo studios were back in force. In the days of the Taliban, all of these seemingly common, day-to-day things were strictly outlawed as sacrilegious.

I THINK THERE WAS some presumption in the West that all women in Afghanistan would immediately shed their burkhas the very second they no longer had to wear them. But the change is occurring slowly, partly because of the men's reaction to seeing women uncovered in public for the first time in five years. After a very short time being there, I found it easy to

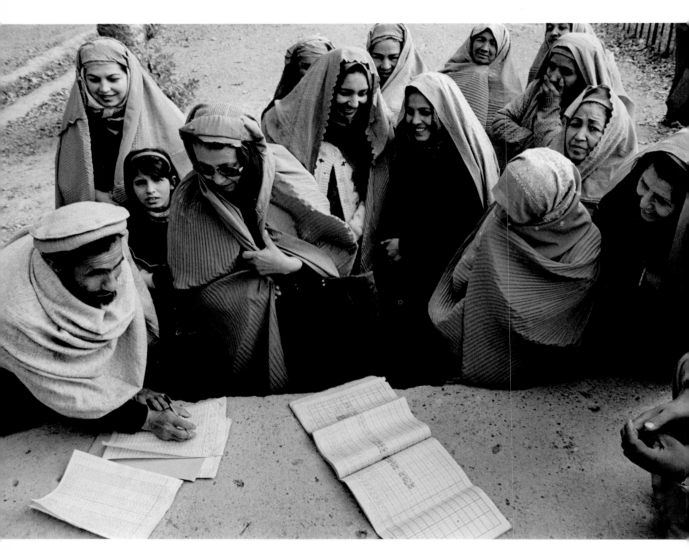

Women at Zargoona High School register to teach legally for the first time in five years.

understand why they kept covered: the streets have become predatory. Everywhere I went, there were huge crowds of men staring at me. "You can see why we choose to stay covered," said my interpreter. "These men make us feel ashamed."

Despite their caution, women had begun to enjoy new freedoms: they walked openly, on their own or in small groups, their burkhas flowing behind them. When they stopped to talk with friends (another activity which was forbidden by the Taliban), they uncovered their faces and chatted freely. At Zargoona High School, hundreds of women arrived for registration to teach legally for the first time in five years. The sight of their relief and delight at this sudden change of circumstance was unimaginably moving. In 1997, when I visited Latifa's illegal home school, I had left my driver a few blocks away for fear of drawing attention to it. There I saw twenty little girls learning to read and write in a freezing-cold room, taking a huge risk for themselves, their teachers, and their families by trying to learn when the Taliban had forbidden girls and women from going to school. In 2001, I revisited these same girls in their school and saw them walking to school openly in groups and playing outside, chattering and laughing with one another, no longer afraid of being beaten for simply wanting an education.

But the most humbling experience was once again meeting with the women I had spoken with in 1997. In the bright sunshine, my translator and I climbed back up the sheer path, with its awesome views over Kabul, that led to Shafika's home. There she stood, wearing a red bobble hat, her face crinkled with laughter at seeing me again. And for hours, I watched the animation with which she spoke and I wished the whole time that I could talk to her directly, instead of through a translator. She roared with laughter at the sight of herself in the old photographs she showed me, and her expression turned to anger as she described her experiences over the past five years. As I left her, she wrapped around my neck a heavy red scarf that she had embroidered, and kissed me warmly.

Other women were harder to locate. "It's impossible." Fahrid shrugged as he explained his failed search for Zargoona. "She has moved too many times and now no one knows where she is." I begged him to continue looking and then, when we started work one morning, he turned around to me in the car and said, "Zargoona . . . I found her."

When we arrived, Zargoona opened the door to her tiny, dark apartment, grabbed me into her arms, and immediately started to weep. She had become so thin, she felt birdlike and fragile, and her hair was grayer than four years should have made it. It no longer matters to her who will take responsibility for her country, because she is now dying of cancer. We sat on the floor talking, and she was ashamed that she could not even afford the customary bowl of sweets. She asked Fahrid to buy them so that she would have something to offer me. Zargoona seized me as she talked, her body cracking with the agony of her life. I felt distressed at having to put distance between us to take her picture, and wished that I could do something to make her life better.

But the lives of Zargoona and of all these women can only be made better if they are not forgotten again. As the world moves on to the next story, the next issue, the next event—which it naturally will—these women continue to live in a country that has manifestly failed them through its years of fighting, its neglect of their basic rights, and its inability to see their worth. And although I am in no position, of course, to pass judgment in such a way, I only hope that the future of the women of Afghanistan will be substantially better than their past.

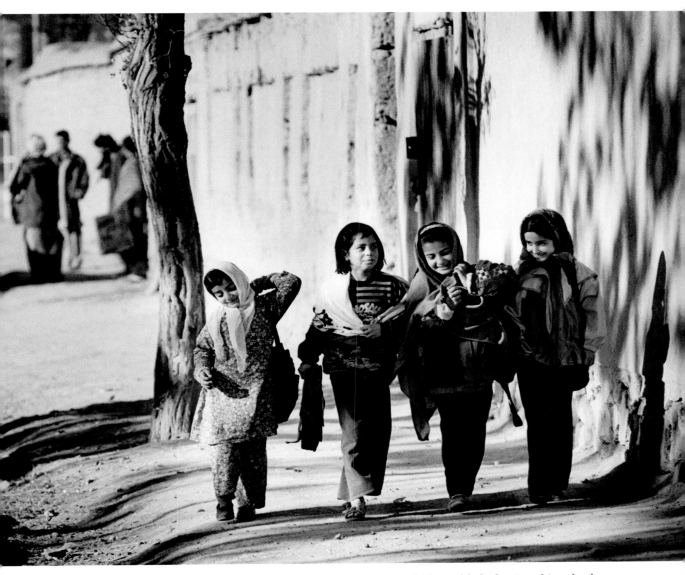

Under the Taliban, girls had to travel to school one by one so as not to draw attention to themselves. Today they are free to walk openly together in groups.

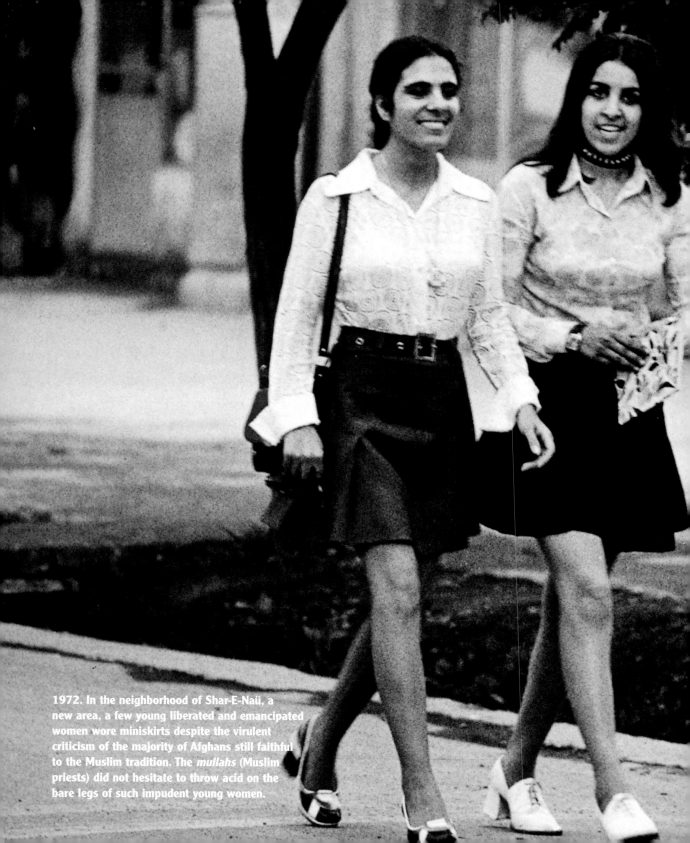

1972. In the neighborhood of Shar-E-Naü, a new area, a few young liberated and emancipated women wore miniskirts despite the virulent criticism of the majority of Afghans still faithful to the Muslim tradition. The *mullahs* (Muslim priests) did not hesitate to throw acid on the bare legs of such impudent young women.

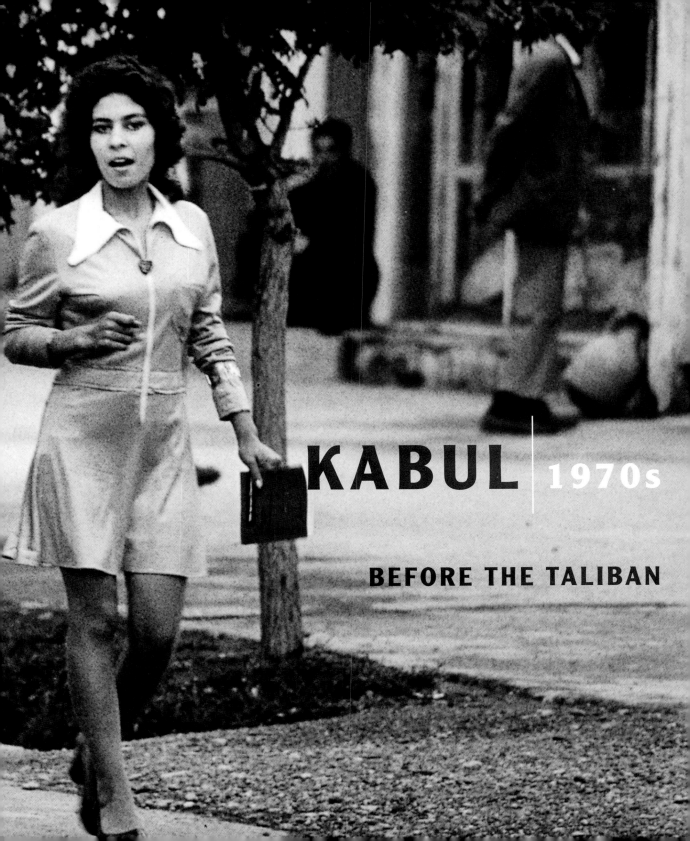

KABUL | 1970s

BEFORE THE TALIBAN

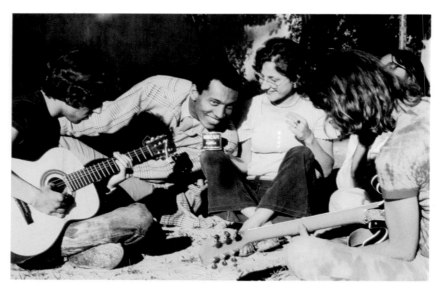

1972. A young woman working with the Peace Corps and her American friends traveling in Afghanistan.

May 1972. Demonstration in the central park of Kabul. The slogans say "Toward peace, democracy, and social progress."

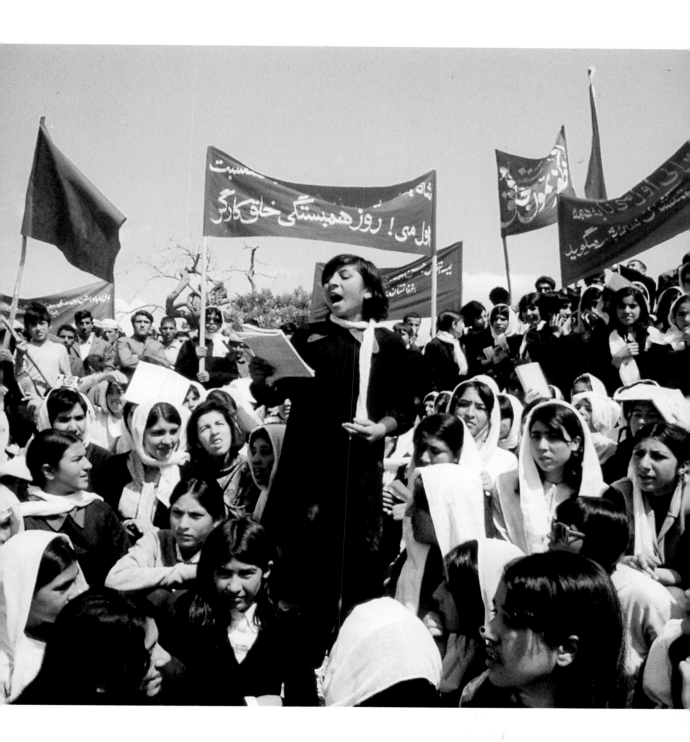

SELECTED

IN SEPTEMBER 1996, THE TALIBAN CAPTURED KABUL AND
IMPOSED STRICT LAWS ON TWO-THIRDS OF AFGHANISTAN.
THESE DECREES WERE HARSHLY ENFORCED UNTIL OCTOBER
2001, WHEN AFGHAN TROOPS BACKED BY U.S. AIRCRAFT
DROVE THE TALIBAN FROM POWER.

WOMEN SHOULD NOT STEP OUTSIDE THEIR RESIDENCES. IF THEY DO, THEY SHOULD NOT WEAR FASHIONABLE
CLOTHES AND COSMETICS. THEY SHOULD NOT ATTRACT UNNECESSARY ATTENTION TO THEMSELVES. IF WOMEN
GO OUTSIDE WITH "FASHIONABLE, ORNAMENTAL, TIGHT, AND CHARMING CLOTHES," THEY SHOULD NEVER
EXPECT TO GO TO HEAVEN.

WOMEN SHOULD ACT AS TEACHERS FOR THEIR FAMILIES. THEIR HUSBAND, BROTHER, AND FATHER ARE
RESPONSIBLE FOR PROVIDING FOR THE FAMILY (FOOD, CLOTHES, ETC.).

WOMEN ARE NOT PERMITTED TO WORK OUTSIDE THE HOME OR GO TO SCHOOL.

NO MUSIC IS ALLOWED. SHOPKEEPERS OR DRIVERS WITH CASSETTES WILL BE IMPRISONED. NO DRUM PLAYING.

NO LAUGHING IN PUBLIC.

NO BEARD SHAVING OR CUTTING. PERPETRATORS WILL BE IMPRISONED UNTIL THEIR BEARDS GET BUSHY.

NO KEEPING PIGEONS OR PLAYING WITH BIRDS.

TALIBAN DECREES

No FLYING KITES.

No PICTURES OR PORTRAITS. THEY ARE CONSIDERED IDOLATRY AND MUST BE REMOVED FROM HOTELS, SHOPS, AND VEHICLES.

No GAMBLING. PERPETRATORS WILL BE IMPRISONED FOR ONE MONTH.

No BRITISH OR AMERICAN HAIRSTYLES ALLOWED. PEOPLE WITH LONG HAIR WILL BE ARRESTED AND TAKEN TO THE RELIGIOUS DEPARTMENT TO SHAVE THEIR HAIR. THE CRIMINAL MUST PAY THE BARBER.

No WASHING CLOTHES ALONG THE STREAMS IN THE CITY. YOUNG LADIES WHO VIOLATE THIS RULE SHOULD BE PICKED UP IN A RESPECTFUL ISLAMIC MANNER AND TAKEN TO THEIR HOUSES. THEIR HUSBANDS ARE TO BE SEVERELY PUNISHED.

No MUSIC OR DANCES ALLOWED AT WEDDING PARTIES.

No SEWING OF LADIES' CLOTHES OR TAKING OF BODILY MEASUREMENTS BY A TAILOR. IF WOMEN OR FASHION MAGAZINES ARE SEEN IN A TAILOR'S SHOP, HE WILL BE IMPRISONED.

No SORCERY.

EVERYONE MUST PRAY. ALL PEOPLE ARE OBLIGED TO GO TO THE MOSQUE. IF YOUNG PEOPLE ARE SEEN IN THE SHOPS, THEY WILL BE IMMEDIATELY IMPRISONED.

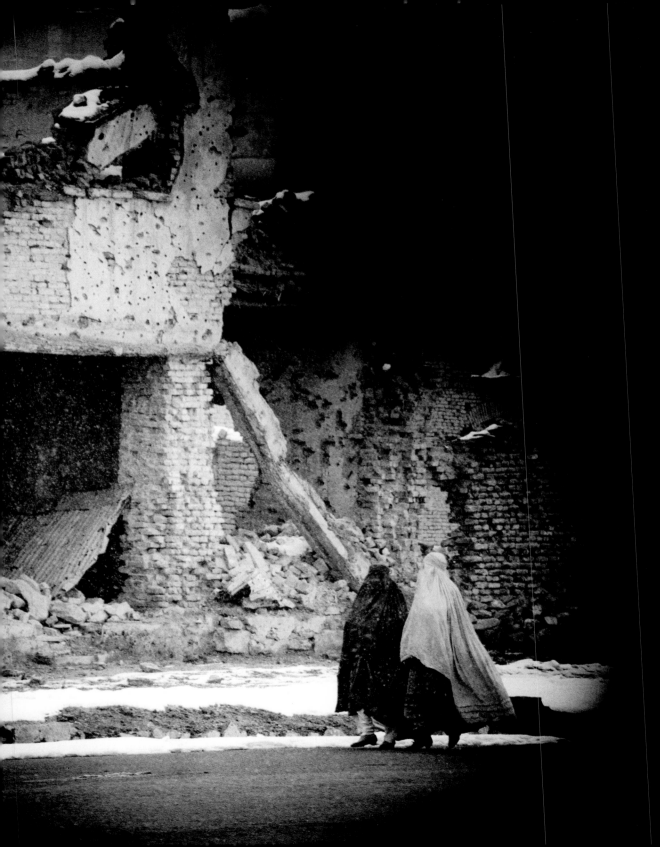

KABUL | 1997

DURING TALIBAN RULE

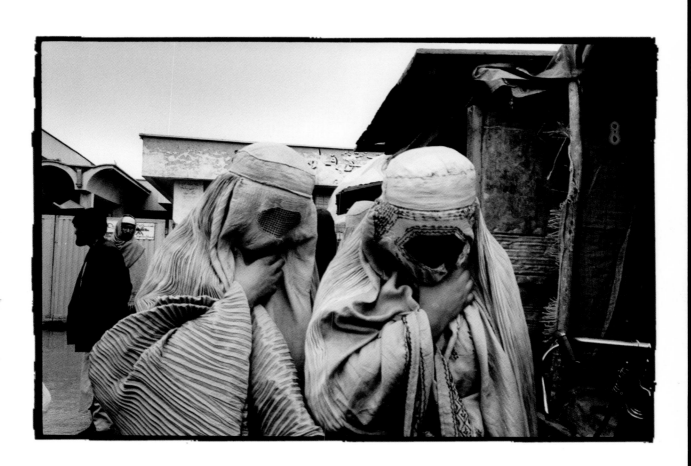

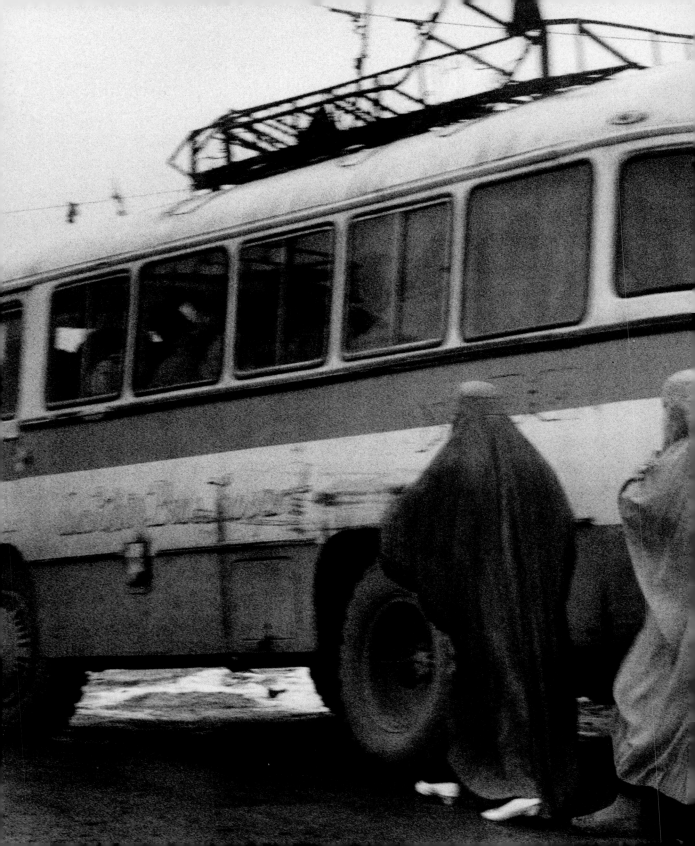

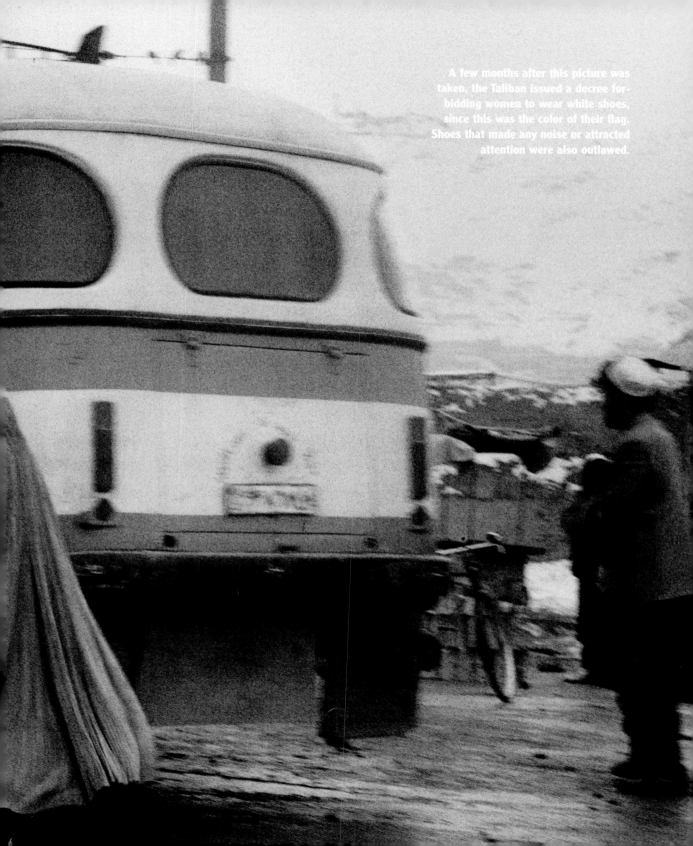

A few months after this picture was taken, the Taliban issued a decree forbidding women to wear white shoes, since this was the color of their flag. Shoes that made any noise or attracted attention were also outlawed.

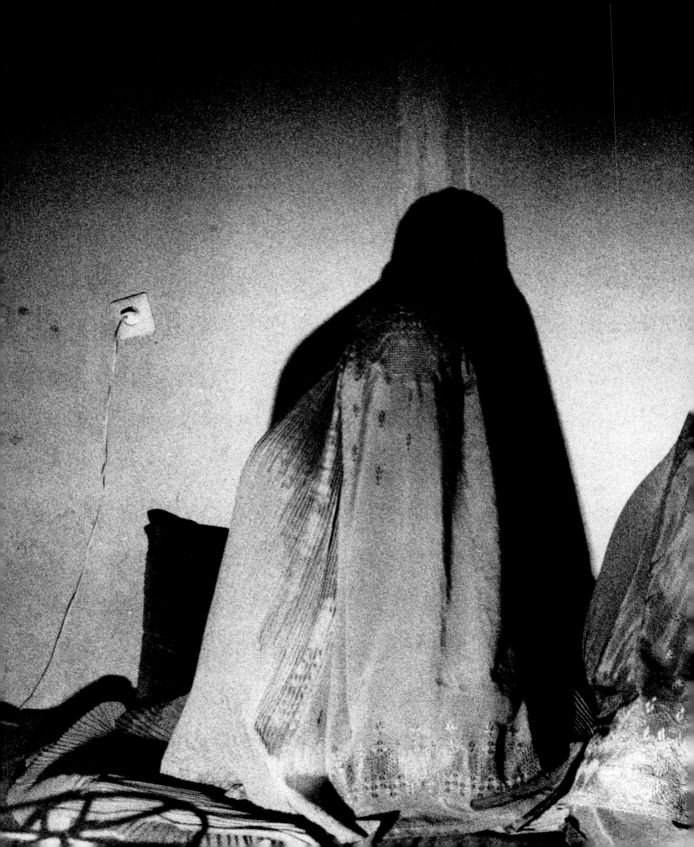

JAMILA & FERSITTA

1997

JAMILA AND FERSITTA are sisters. Jamila was twenty-four and had worked as a radio journalist before the Taliban took control of Kabul in 1996. Fersitta was twenty-five and had also worked as a journalist.

When I first met Fersitta, she asked me to come to her home to interview and photograph her. On a freezing-cold night, I arrived at the Microrayons—a Soviet-built complex of high-rise apartments in Kabul where she lived. When I entered her home, she told me that she was too frightened to be photographed with her face showing. I photographed her and her sister Jamila wearing their burkhas by the gaslight in their sitting room. They had no electricity. When I had been there for less than an hour, their elderly father came into the room and asked me to leave. He said he was terrified of what would happen to them if the Taliban found out I had been there. He was visibly upset by having to ask me to go, however, and begged me to come back when the Taliban had left.

I tried to find Jamila and Fersitta during my second visit in 2001, but when I went to their building, I was told that they had left the country.

JAMILA

We had a better life under the Communists in the 1980s. We could work and educate ourselves. We could go where we wanted. It was good for women, but bad for Afghan men at that time. They had to go to the front lines and fight against the Russians, and they were desperate because they often had no chance of survival. I was nervous whenever my brother had to go fight.

Before the Taliban, I had lots of tape cassettes like Michael Jackson and some Iranian and Indian pop singers. I like pop songs, not rock. We don't know about recent music. I haven't been in Europe or America and I don't know what your music is like. My family sent my brother to Moscow, where he was able to save some money, and after that he made it to Holland, where he lives now. It's very important that someone from our family has made it out of this miserable situation.

I've never had any boyfriends. It's not important for me to have one. It's not in our culture to have boyfriends as it is in yours. Marriage depends on my family. It's a decision between the families—not up to us. It's very rare for a couple to fall in love and marry for love. I haven't met the kind of man I want to fall in love with, and I can't trust Afghan men outside my family, because they can be very dishonest. I want a man who really knows me and what I want out of life, someone who lets me do what I want, who does not prevent me from doing anything, and who treats me as a colleague and an equal.

I have heard about the increase of suicide in this country, but I find it hard to believe. Suicide is not in our culture. Anyone who does that must be a recluse from the world. The person would have to be really desperate—but I know that there are women who are living a terrible life here now. It makes me very upset to see women begging on the street. Every day, the numbers of them increase and it makes me feel sick. There are even teachers from my college who have been forced to turn to begging to support their families. Every day people come to my front door: men, women, and children asking for money.

During the day, I keep myself busy studying English and helping my mother around the house. She's sick, so I must do most of the housework alone. I read poetry books, and I've got basic English books and stories like "Ali Baba and the Forty Thieves." We don't have much information from the rest of the world. We can only listen to Radio Sharia, which is played here, and we do not hear any music on that, of course.

I like the idea of London very much, and although I've never been, I have relatives who live in England. But if I ever went, I don't think I could return to Afghanistan again.

My biggest ambition is to get my job back. My father wants me to go to London to work for the BBC Pashtun desk. He thinks it would be very good for me. He says he will not miss me and that my advancement is his happiness.

FERSITTA

I loved my job. I was very successful and had a good life in front of me. My parents are nervous now. They were proud of me then, but now I can't work. The Taliban won't allow us to have a voice. What can we do? It's not just the Taliban, either; I've never had any good memories of this country. Not from the time of the mujahideen and certainly not under the Taliban.

Under the mujahideen, women had the power to speak, but the security wasn't tight. Every commander was a government by himself and it was hard to take a stand against them. But at least we could work. Before the Taliban, men would look at us with sexual desire. If they wanted us, they could just drive up in a car and take us. Now, with our burkhas, no one knows what we look like, and we feel safe. A commander can no longer just take us from the street. When we meet men, we keep covered. The Taliban prohibit us from talking openly with our friends. We can't talk for a long time when we see them on the street. One time, the Taliban even took a couple to court to prove that they were married after they found them talking on the street together!

When I meet my old friends on the street, we laugh because it's funny to see one another under the burkha! If I pass someone I know on the street, I quietly say hello, but often they don't know it's me. We women went to collect our salaries right after the Taliban arrived, and we saw men that we knew. They kept saying, "Hello, whoever you are." We women know one another on the street by our shapes. We recognize our characters. When I am among my friends, they know me. They know the way I walk. I walk as I always have, and even through the burkha, they recognize me.

Under the Taliban, makeup is prohibited, but I wear it anyhow—eyeliner and lipstick. We do this as a symbol of defiance. It's our way of not obeying what the Taliban say.

We are very sad. Women are not getting an education, and we don't know if we can ever resume our lives again. At first, we had heard rumors that the Taliban were good people. But we were not aware of the rules that they would impose. When we heard about the burkha, we cried—all of us. When I first covered my face with the burkha, I was ashamed. I felt deprived—I no longer had the liberty that the other women in the world had.

I can't express my feelings and what I really wish for. Sometimes we hope that a government like Massoud's will come back and the Taliban will go. Maybe the Taliban will relax and let women out if they begin to feel confident enough about their control. Or maybe a new government will come and stop this barbarity. We want peace and liberty in Afghanistan. When we see Western women in Kabul, we think that they're very lucky. We respect foreigners in Afghanistan for coming to this terrible place. We feel very sad that we have nothing.

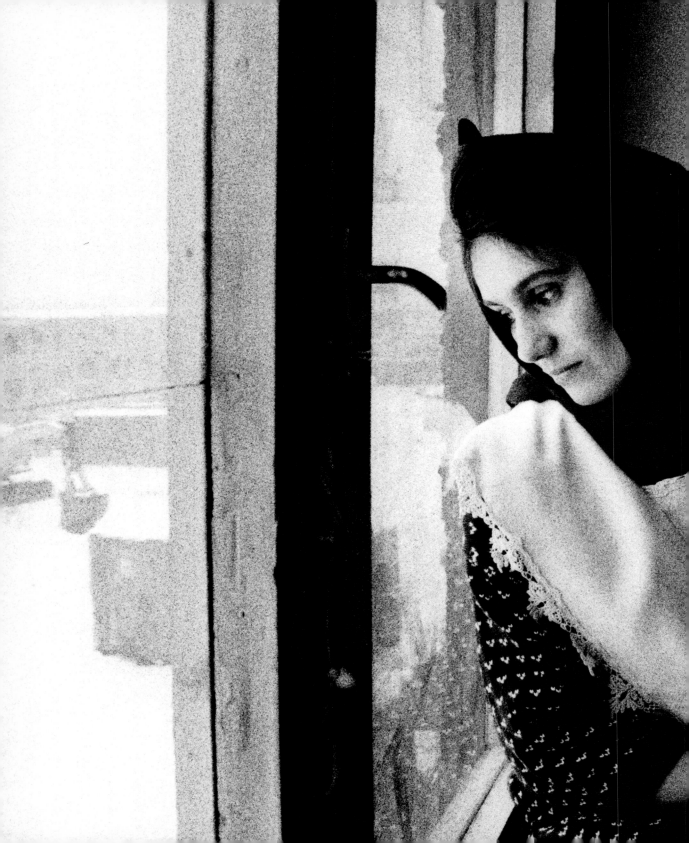

Jamila, 1997

MARINA

1997

In 1997, I spent six days with MARINA, who was my interpreter. When I returned to Kabul in 2001, I was told that for the past two years, Marina and her mother had been living in America.

For Marina, putting on makeup was a sign of defiance against the restrictions imposed on her. The Taliban, however, were strict in their punishments and reportedly cut off the lips of women found to be wearing lipstick.

I want to fight with my pen. I would fight by force, with a gun, but I'd have to kill people. I don't want to do that, even if they aren't good people. They don't need to be killed, they need to learn how to become human. And if they are killed, Afghanistan just loses even more people than the millions that have already died.

I love to learn. When the Taliban told me I couldn't go back to university, I was very depressed. After two months, my family sent me to Pakistan to recover. When I returned from Pakistan, I still cried every day. Then I tried to commit suicide. I couldn't forgive my mother for not allowing me to stay in Pakistan to continue my education. I wrote a note that said I wanted my grave to be next to my father's outside of Kabul. Then I ate fifty sleeping tablets.

My mother found the note I had written on the refrigerator and found me in bed going to sleep. I really wanted to die. We are just in jail living like this, and I couldn't bear it. But my mother came home early and found me. When my friends found out, they said they wanted me to live—not for me, but for them. They were not angry with me; they were just sad.

The next day, I felt normal except for some red marks on my mouth from the potassium my mother made me take to get sick. But I had been in a very deep sleep. My brother was extremely angry. I told him that what I do is up to me, not him. He said, "Okay, then throw yourself under a car outside so that no one knows it was suicide. How could you do this at home when you know that we can't accept it?" My mother is worried that I will try again. As a last resort, I will.

I want to leave this place.

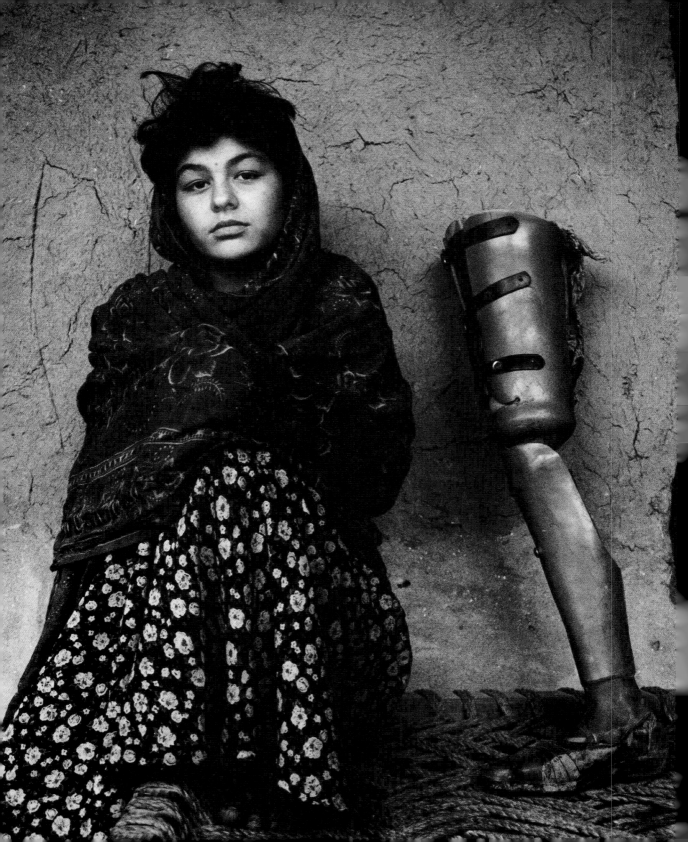

1997

FAHRIDA was fourteen years old and lived with her parents, five sisters, and three brothers. She lost her leg during a mujahideen rocket attack, which also killed the two children she was playing with.

FAHRIDA

So many people talk about how bad the Taliban are, but I don't think they're right.

Eight years ago, when I was seven years old, I went out into the street to play with some of my friends. We weren't doing anything wrong—just playing on a quiet street—when the shell landed. It killed both of my friends, and their blood was everywhere, and I have to remember that day and the bad things I saw. Can you imagine?

I was the only one who survived, but I lost my leg. That means my life will always be hard for me to live.

I hate the mujahideen for doing this to me— they took away my leg and, with that, my freedom. They took away my friends, who didn't deserve to die in such a way. How could I think them good?

Of course, the Taliban will be better for us than those terrible men were. I don't think there is anyone who could do such a bad thing to me again, and I never want the mujahideen to return.

DECEMBER | 2001

LIFE BEYOND THE TALIBAN

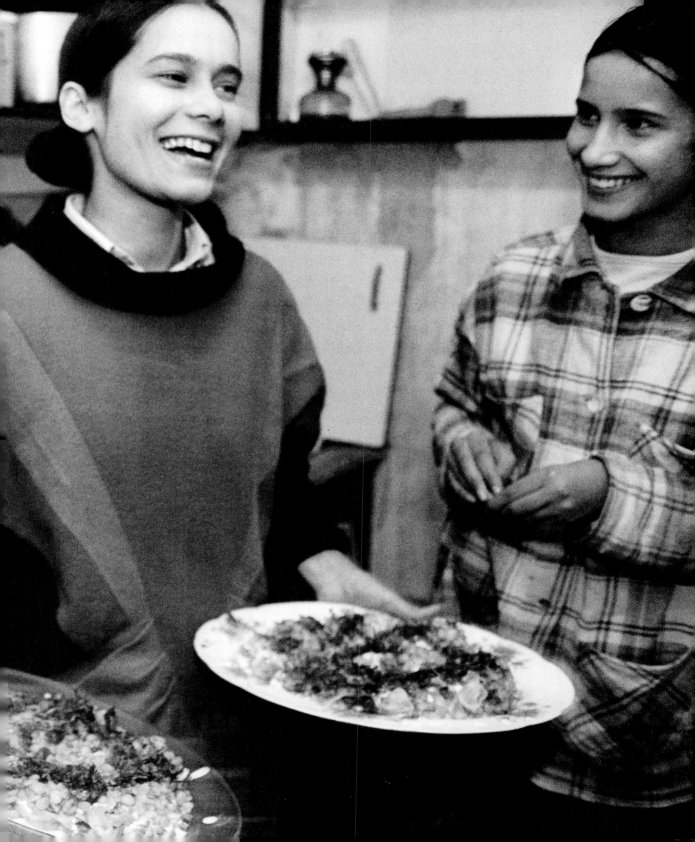

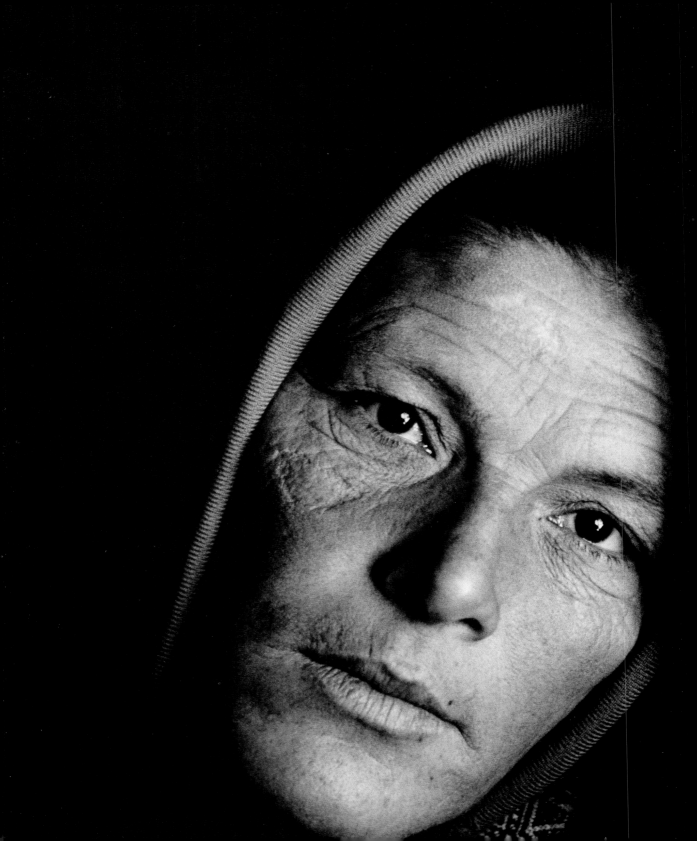

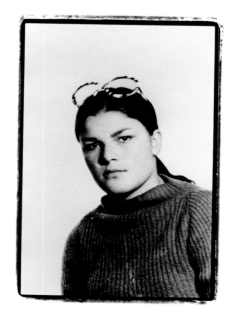

Shafika, 1970

SHAFIKA

2001

When I met SHAFIKA in 1997, she was anxious about taking care of her fragile, ailing mother. Her mother's illness required a lot of Shafika's time and attention, but so, too, did supporting her family.

In 2001, I visited Shafika in the same house that she lived in when I met her in 1997. Her mother had since died. Shafika lives there with her daughter, Roya, and the three children of her deceased brother. She is fifty-five years old and works for a carpet-making project.

I have been widowed now for fifteen years. Since childhood, my life has been very difficult. My family was very poor and five of my six brothers died. My father also died when I was a child, so my mother worked as a servant. She washed clothes for neighbors and did whatever she could to survive. I remember that there was always fighting in Kabul and I remember when the Russians were here. For years, we had to keep moving our home, but there was no place safe to go.

I was nineteen years old when I got married. My husband was a taxi driver and we were together for twenty-one years. He was a kind man, and while he was alive, I suffered no pain. I didn't need to work because he supported us. One day, he died suddenly in the street from a heart attack. After his death, I tried to find work anywhere I could, but because I only made the sixth grade at school and have no qualifications, getting a good job is difficult. I still keep looking. I have gotten into terrible debt with my friends and neighbors.

Does anyone have any good memories of the Taliban? I certainly have none. I only have bad memories. One day, the Chief of Prohibition of Vice and Promotion of Virtue, along with eight men with guns, came to my house and accused me of working on wool projects inside the house. They shouted at us, and we were very scared, but they did not hurt us. Another time, I was walking in the street. Some Talibs were beating a woman and I went over and asked, "Why are you beating her?" They started to beat me too for asking

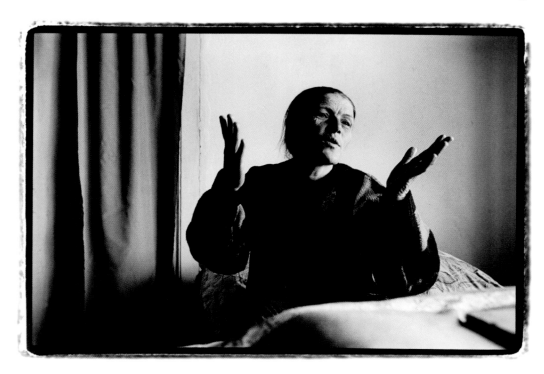

"Does anyone have any good memories of the Taliban?"

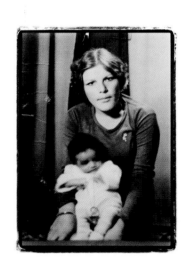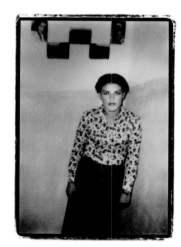

Shafika, 1970

Shafika, 2001

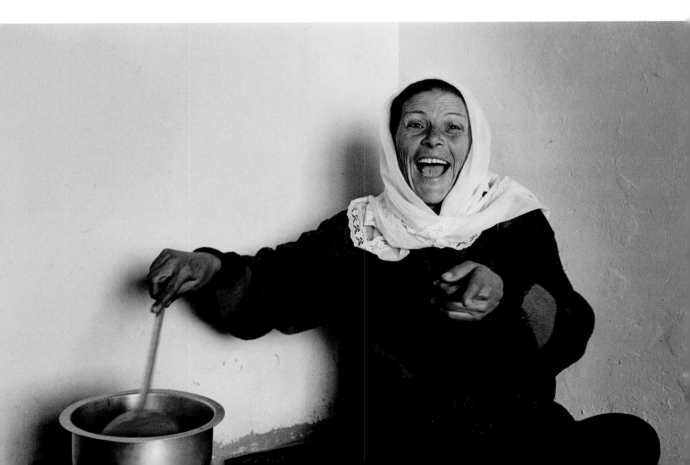

that. They gave me five lashes with a leather whip. I managed to escape and ran away as fast as I could. Every time I left my house I worried. In every place I saw Talibs and I lived in fear.

During this time Mary [MacMakin] gave me some work at PARSA running the wool project as a team leader. We worried all the time about being followed, and we worked in secret. If the Talibs saw us with the wool, we told them we were just making rugs at home. We couldn't tell them, of course, that we were working and that we sent the rugs to Pakistan to be sold. I was paid fifty dollars per month. It was difficult to survive, but we managed. The Red Crescent also helped me. They gave me rice, wheat, oil, peas, and salt every three months.

When the U.S. bombing started, we were afraid because the television transmitters, which they targeted, are very close to my home. My house was shaking so hard that the upstairs windows broke. I don't have radio or television, but I knew that it was America bombing because of the sound of the planes. Foreigners like Pakistan and Osama bin Laden supported the Taliban. They have strict and strange ideas and their beliefs are not to do with Islam.

Women usually still wear burkhas here. When the situation gets better and we have a new government, we will take off our burkhas. I never wore this thing before the Taliban came to power.

I am not angry with all men: some men are good. And in the future, Allah will direct men not to fight anymore. He will look after us. We should not have these armed men all over the city, and they must be disarmed if peace is to return. Maybe these past wars between the mujahideen will not be repeated. Maybe now we will learn from their mistakes.

Enough is enough.

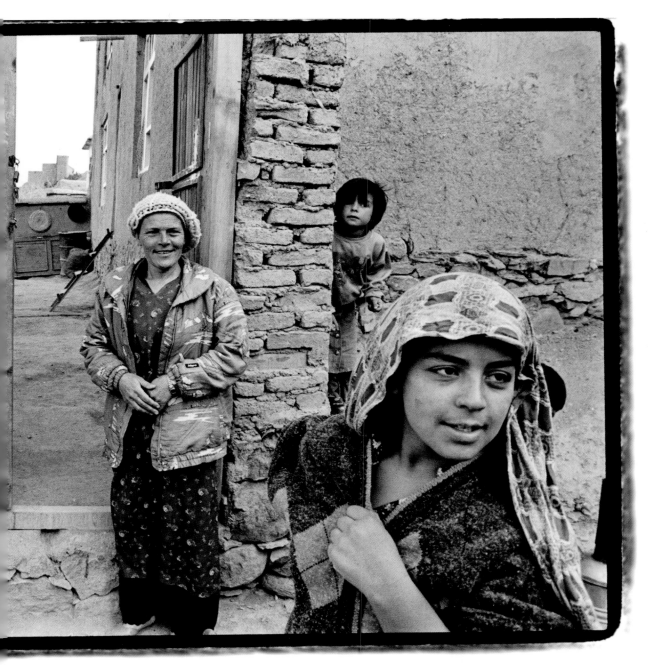

Shafika and her daughter, Roya, at home

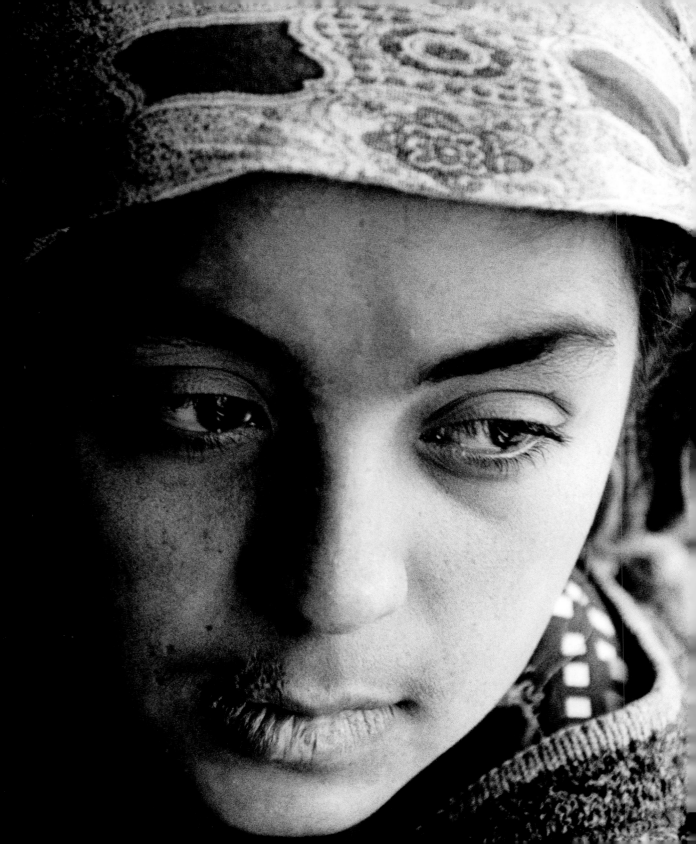

ROYA

2001

ROYA is fifteen years old. She is Shafika's daughter.

I was in school when the Taliban came to Kabul—I enjoyed learning very much. My favorite subjects were math and Dari [the most common Afghan language]. I was ten years old. I don't remember much about the time before. I was told that they would not allow me to go to school anymore. That made me feel very sad. I have been working here at home for the last five years, helping my mother with the house chores.

While the Taliban were here, my mother worked illegally. While she was gone, I would look after the house and my grandmother, who was dying. I worried every day when my mother left the house that she would be arrested or beaten. But she had no choice but to work—my father is dead. I hated the Taliban for that—they knew there were many widows here in Kabul who had no way to support their families if they couldn't work. These Talibs were very bad people.

We have no legal relatives, so when I had problems with my tonsils, I could not go to see a doctor. We also have no money to pay one.

I hope to be able to go back to school and study. Then after that I would like to work. I don't know about the future and if there will be peace. That is up to Allah.

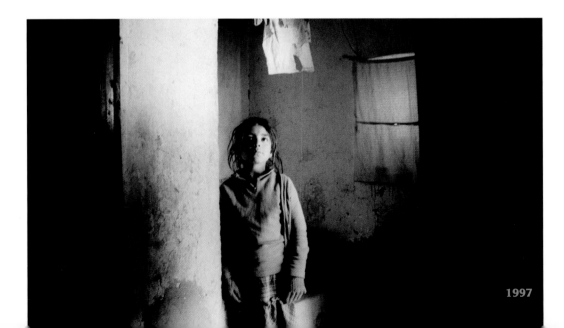

1997

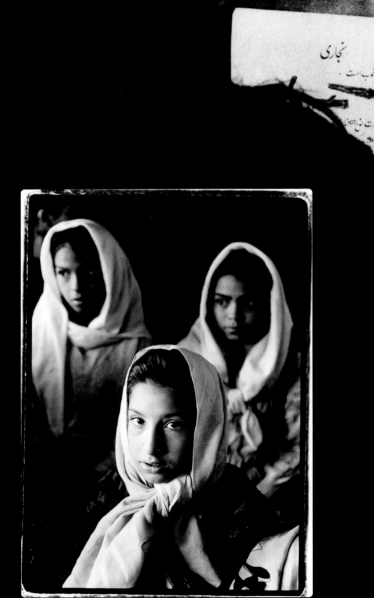

به زودی تمام کافران داخلی و خارجی را از
وطن ما آزاد می شود .

جان پدر : ما و شما هم ماجان و دیدار
آزادی وطن اسلامی خود را برقراری ...
اسلام جهادی کنیم .

لغات :

نجاری
... کتب خوب است .

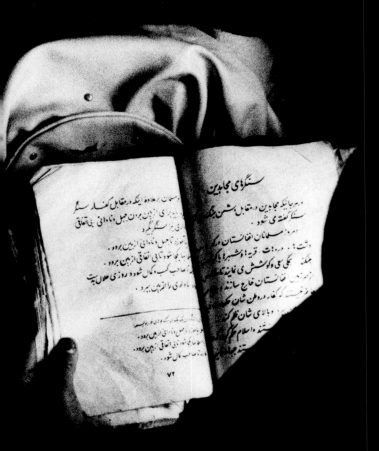

LATIFA

2001

LATIFA is a thirty-nine-year-old widow with five children. Four years ago, I visited Latifa while she taught twenty girls to read and write in the school she ran illegally from her home. In December 2001, I visited the same school, which was now running legally, just weeks after the Taliban left Kabul.

I was born in Kabul. My childhood was good, but now I live in a rented house, and life is difficult. I was twenty years old when I got married, but after ten years, I lost my husband. He worked as a guard outside an office, and a man walked up and shot him one day. He was just doing his job, and no one knows why they killed him. I was three months pregnant then—a terrible time to lose my husband like that. I became very depressed, and after Yelda was born, I was very sick.

I supported my three boys and two girls by working as a teacher. During the time of the Taliban, we had difficulty running these schools. We told our girls to hide their books under their veils, or wrapped in their clothes, or in copies of the Koran. We were often followed by the Taliban. And we lived our lives in total fear of what would happen if they were to capture us, or the children we were teaching.

One day, a six-year-old student left the class and started walking down the street. Suddenly, a car full of Talibs stopped, and they grabbed her and started searching her bags and shouting at her. They wanted to know where she had been and who had been teaching her. They accused her of learning about Christianity. She just cried and cried. They didn't beat her, perhaps because she was so little. But they pushed her around, threw her bag on the floor, and shoved her to the ground. She was terrified, but she never said where she had been.

I was watching all this from these windows. I couldn't do anything; if I had gone to help her, the Talibs would have beaten or arrested me. That little girl was so brave to bear those things by herself.

One reason I took the risk and kept teaching was to make sure my children didn't starve. But I also felt that it was very important for all these girls to continue with their education. Why should ignorant men deny our daughters such a right? Before the U.S. bombings, we were teaching fifty students a day—just girls. Many people left when the bombing started, but we still teach about forty per day now. I teach in the mornings from 8:00 A.M. until 11:00 A.M., just as I did when the Taliban were here. But so much else has changed—for the better—recently. It is amazing to go to work now with no sense of danger or fear. My students come in big groups together. Before, they would walk on their own to avoid attention from the Taliban.

I am very optimistic about our future. We are like a new baby, and we still believe, after all these years, that peace will come. I walk around the city and it's like a different place now. So much has changed so quickly. I see women walking alone or in taxis on their own without the need for an escort.

People walk calmly, without any fear. And there is much happiness now.

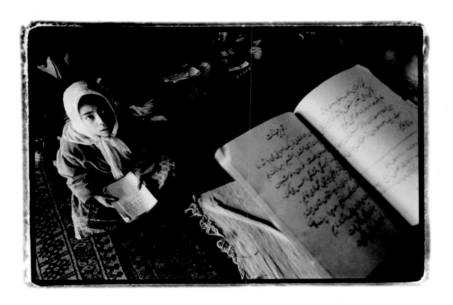

In 1997, girls at Latifa's school had to hide their books inside copies of the Koran or inside their veils. They risked beatings of themselves, their parents, and their teachers simply for wanting an education.

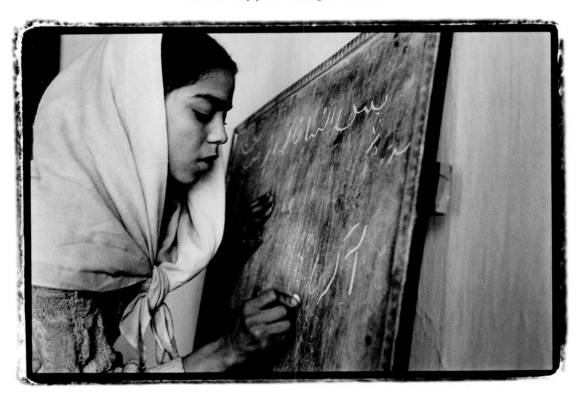

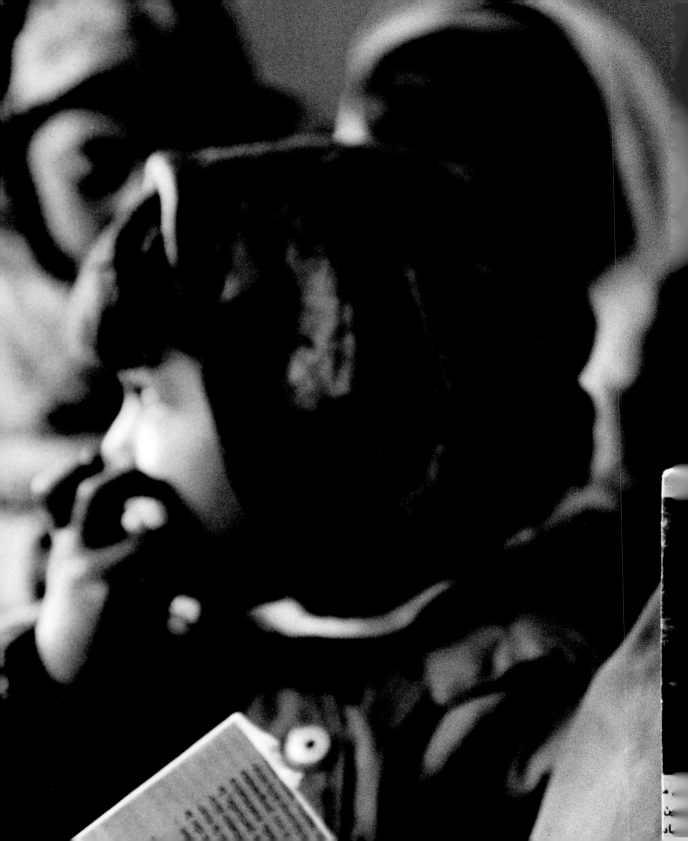

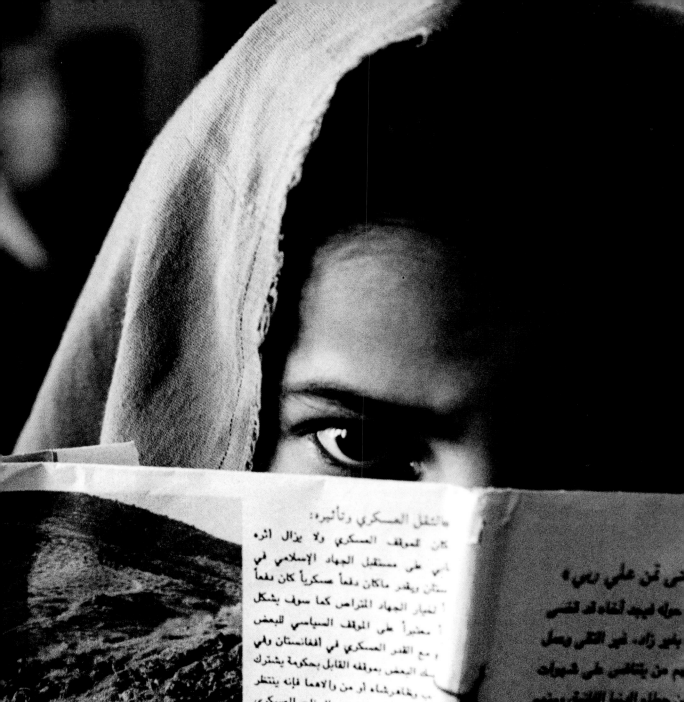

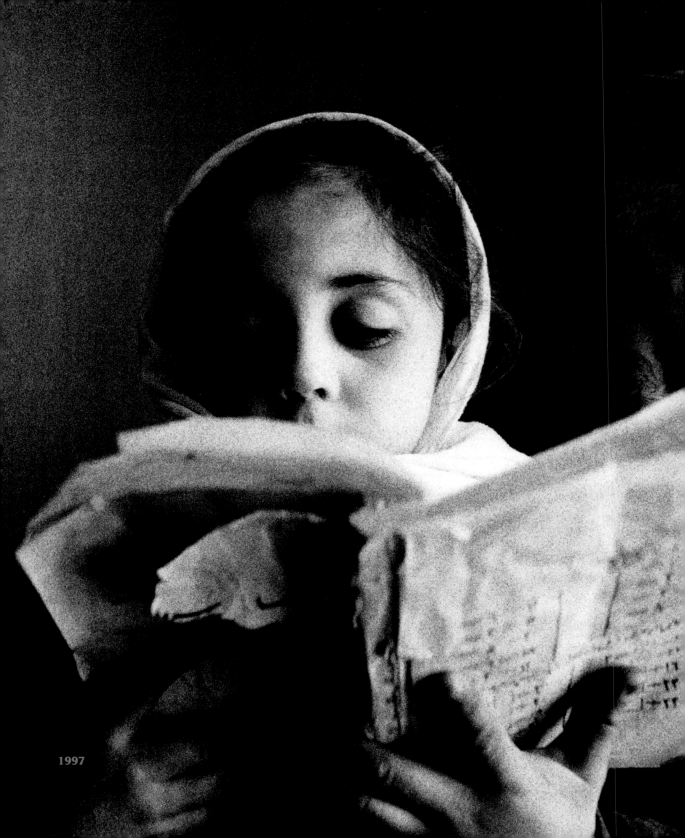

1997

YELDA

2001

YELDA is nine years old. I first met her in an illegal home school in 1997 where her mother was teaching. There were twenty little girls sitting on the floor of a freezing house learning to read and write.

When we went to school, we hid our books inside the holy Koran. I knew that if the Taliban caught me going to school, they would beat me. I think the Taliban did not want us to go to school because they wanted us to be stupid. The Taliban said, "Boys are men, and girls are women, and women don't go to school." It made me angry and upset that they did this to us. Boys went to school without hiding their books, without any fear, but we went in secret.

I like all of my subjects in school very much. And I also like cooking. I want to finish my education and become a doctor. I am happy now that the Taliban have gone and I can go to school freely. I can also watch television and I watch children's programs.

I want to study and go to school. That's because in the end, I want to help my people because they are very poor.

I want children in other countries to go to school. Studying is a good thing for everyone.

Children should be brave like we Afghan girls have been.

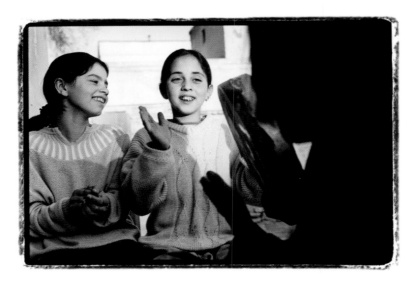

December 2001. Today Yelda and her friends can openly sing songs and play drums.

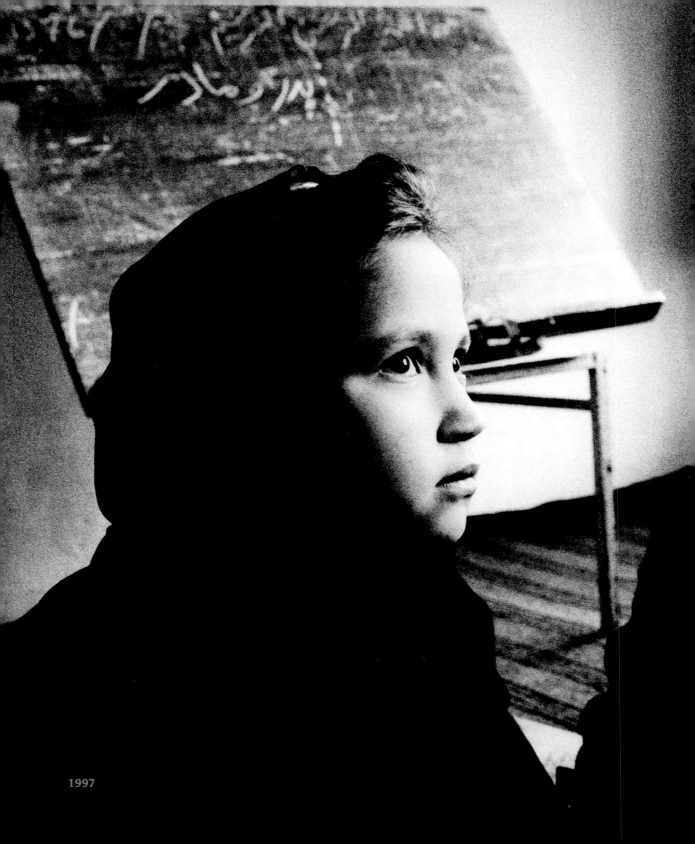

1997

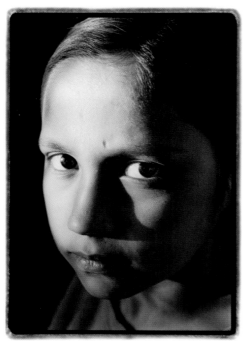

SOVITA

2001

SOVITA is ten years old. I met her in 1997, when she was six, at the school she is now able to attend legally.

I remember what it was like to go to school during the time of the Taliban. I wanted to keep going but I was scared because my school was near my home. What if the Taliban caught me and made me take them to my house so they could beat my parents too?

Every time I did the short walk I did it with fear and I did it alone.

The Taliban children didn't go to school—they couldn't read or write. So the Taliban parents didn't want us to be smarter than their kids.

I don't know what made them like this.

If I had power and I was a commander and a Talib came to me, I would execute him.

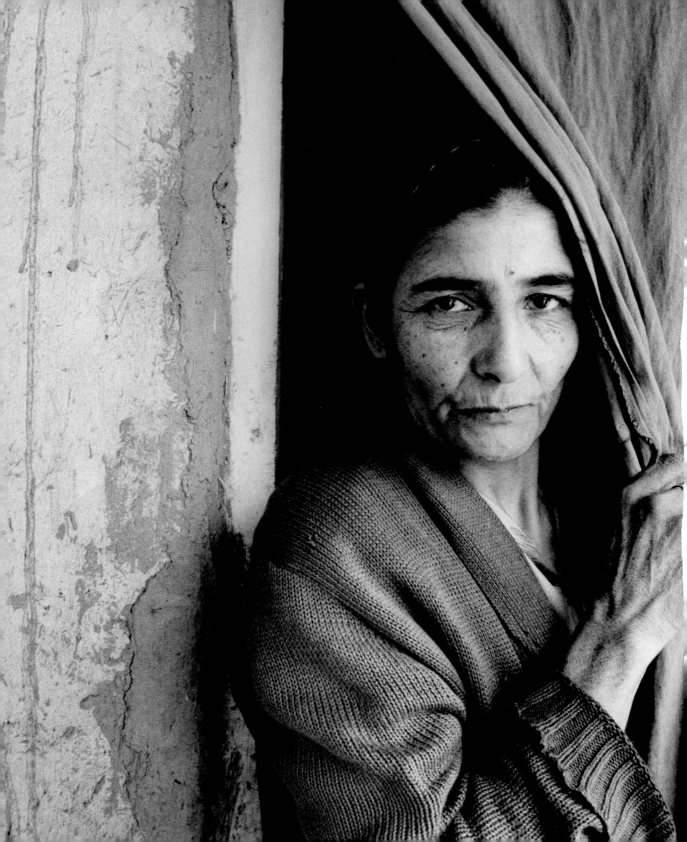

AQELA

1997

I first met AQELA in 1997. She was living in a rented house with her daughters Nooria, Nasera, and Basera and her son, Shohib. She has two other daughters, Adela and Saleha, who are married. Aqela has supported herself by working as a cleaner for Mary MacMakin's organization, PARSA. Originally from Kunduz, Aqela was married in Kabul. Her husband, who worked as a handyman, was from Gazne and suffered from epilepsy. He was killed by a rocket explosion in Kabul several years ago, when the mujahideen came.

Before I got this job working for Mary [MacMakin], I had been forced to beg on the street in order to support my children. It was terrible. The Taliban forbid me from cleaning houses like I used to, so what choice did I have? My husband is dead and I trust no one in this situation—you cannot even trust your own brother, and we are desperate for money. Every time I leave the house I think I will be caught and beaten. My friend was beaten at a bus stop one day, for no reason. When we asked why, they just hit her harder. Now you understand why we are frightened living with the Taliban.

I can only afford this one burkha, which means I have to share it with my daughters. We must take turns if we need to go outside the house! But my situation could be worse: I know women here who have become so desperate they have taken their own lives. They use poison to kill themselves, and some even poison the food they feed their children to kill them, as well.

There is something wrong with my son. He cries and screams loudly, and he has started to bang his head on the floor and hit himself. We have to hold him down to stop him, and I worry about what will happen if we are not around one time when he's doing that. That's why we can't leave him on his own. If I had the money, I could take him to a doctor, where they could treat him. There must be something he can take—some pills—to make him better.

But at this point, we can only just afford to feed ourselves. It is so cold here. We only have a few blankets to sleep with and all the heat we have is from this [wood-burning stove]. Every day when we go to get water from the well outside, we have to break the ice first with rocks.

The people of our country have no one to complain to about the difficulties with the Taliban.

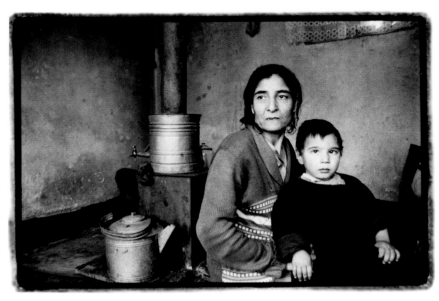

1997

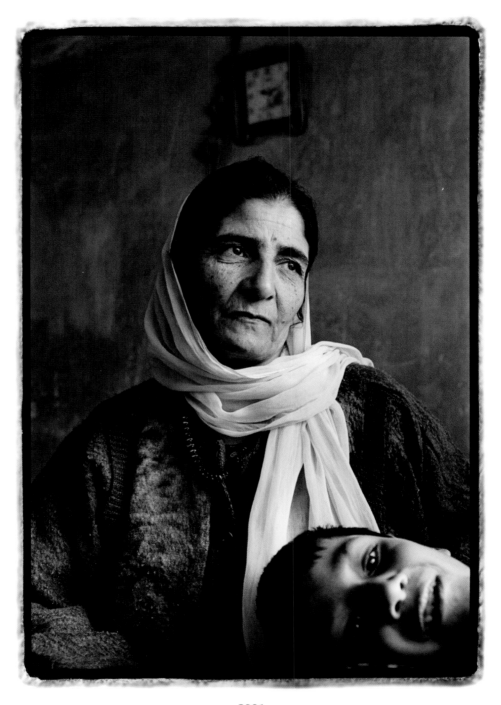

2001

2001

AQELA's son Shohib, who is now seven years old, is mentally retarded and suffers from epileptic fits. When I first met him as a three-year-old child, the extent of his problems was not fully realized, but even then, he would bite himself and bang his head on the floor when angry.

I am maybe forty—I don't know. I cannot remember a good situation in my life, not when I was a little girl—never. Not even when I was married.

Once, when I was a little girl, I found an earring on the street—I took it home and showed it to my father. He beat me very hard and asked, "Where did you find this? You stole it. Take it back to where you found it and leave it there." My parents were always very poor and I was never able to have an education.

I had no hope that the Taliban would fall—they were so strong and I never thought they would disappear. Allah helped make them disappear.

When Mary [MacMakin] went to Peshawar in July 2000, I had to go with her in order to support my family. I had to leave them in Kabul. Every day I cried. I missed my family too much—especially my little boy. When the bombings happened, we watched on television from Pakistan. I saw the explosions and cried a lot. My children called me once to tell me that they were okay, before the telephones stopped working. Then I worried so much. After the bombings, one of the staff brought a letter out from Afghanistan for me that told me they were happy and safe. I just arrived back here yesterday from Peshawar, and this is my first time here without the Taliban.

I worry about my future without a son who is capable of supporting me, and for the rest of my life, I know that my boy will be on my shoulders. Every time I look at my son and see his madness, it hurts me. I worry about him so much that I can't breathe properly at night. What will become of him? He is seven years old and he hits his head on the floor. He bites himself and shouts loudly. I want my youngest daughter to have an education so that her life will be better. I have no one to help me with these problems.

I have no home at all now and never have. All my life, I've lived in rented houses and now I have nothing. The house we live in has no windows. We have no money for glass—only plastic.

We have a food card but haven't had any food yet. The food distribution is so hard. So many people arrive for food and it takes so long. There is often fighting, and people panic because the food runs out before everyone can get some.

We've now had twenty-three years of war in Afghanistan, and I don't know what will happen here. We have no good leaders; the commanders are the same as before. I want the United States and the United Nations to help us. We hope our country will be calm, but I am not sure about the future—I just know that we need help from outside.

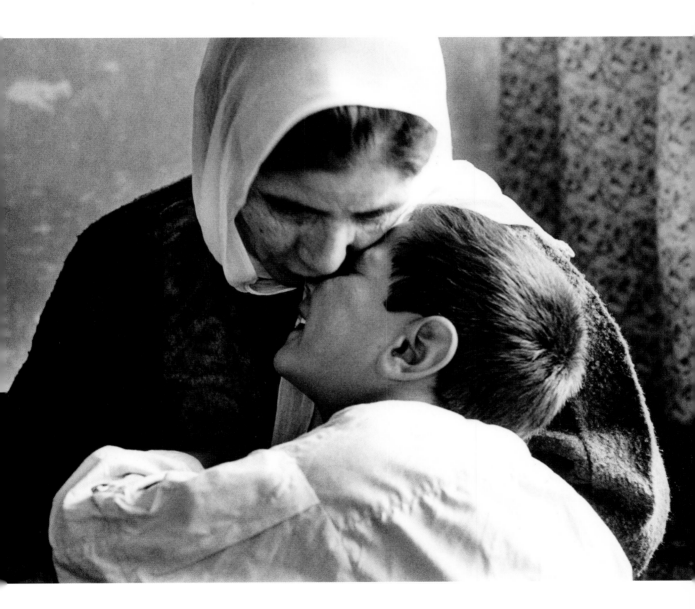

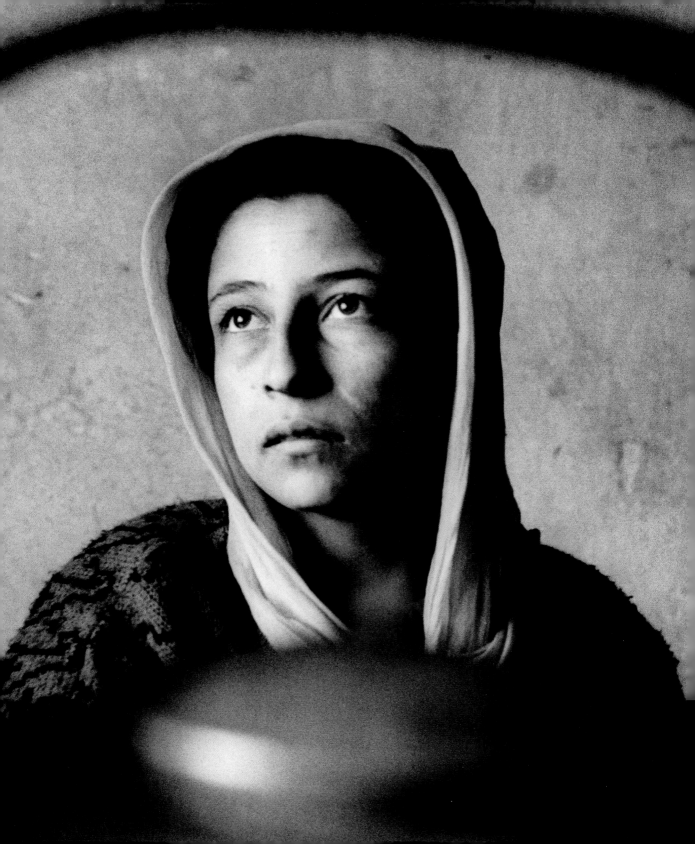

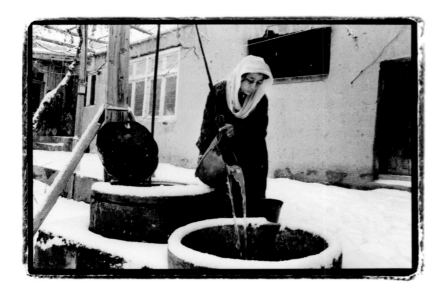

December 1997. Every morning during the freezing winter months, Nooria had to break the ice with rocks so she could draw water from the well.

NOORIA

1997

NOORIA is Aqela's daughter. She is nineteen years old. She lives in a house with eleven of her relatives—five women and six men.

Why do people think the Taliban are so bad?

At least they have brought peace and stability to this country, there is no more fighting, and at last, we feel safe. We can be sure with them that there is order, so things are fine for us in terms of security.

During the time of the mujahideen, I lost my nine-year-old brother in a rocket attack. He had gone to get water for the house and a rocket landed in the street and killed him. There were around sixteen people by the well: eight wounded, eight killed.

I hate the men who cause these problems. We women are not responsible.

I never really went to school much, so this ban on education does not make much difference to me. As long as I don't have a fear of fighting going on, then the Taliban are fine.

2001

I am single.

I have some problems with my health. There is something wrong with my lungs and my kidneys, but I have no money to treat this properly. They just tell me that I should drink a lot of liquids.

So many innocent people have been killed in all these years of fighting. But running the country is the work of men, and it is they who are the educated ones in Afghanistan!

Women are not given the same options as men—with or without war going on—and particularly if they don't have money. I think it's possible for us women to gain some rights now. And I hope the new government will make some changes.

If I ever have sons, I want them to go to school and be educated. Children who are educated are more capable of understanding the rights of women. I would tell my sons to respect the rights of women. Women are life givers. I also want my children to have professions and be successful. I will advise my boys to respect everyone and I'll tell them not to be cruel to women. That was the problem with the Taliban. They were uneducated and they didn't have any respect for people. They just ruled by fear.

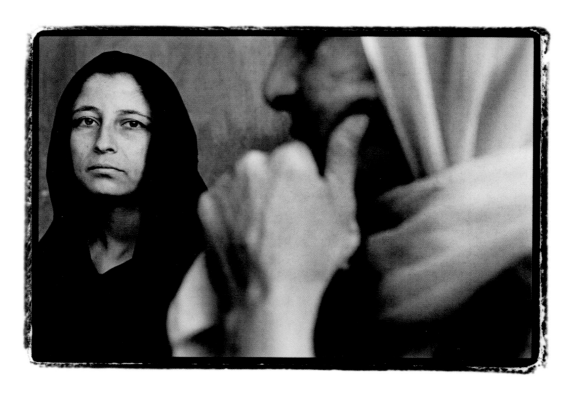

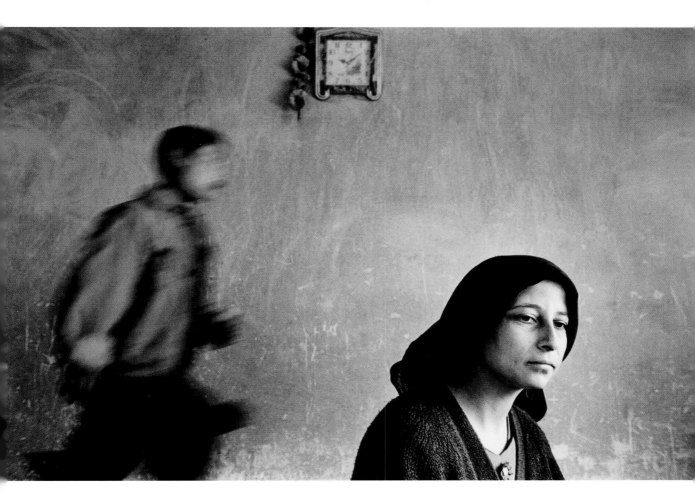

My mother supports me and is the only one to carry this family. The biggest problem that many women here in Afghanistan face is that they've lost their husbands. Then they are left with no work and no men to support their families.

It is getting into winter now, and we do not have any fuel for these cold months. Every day, it gets colder and colder. And we worry about those refugees who are living without power, without a roof over their head. How will these people survive the winter?

It will be difficult for us in the future. I worry about where we will live, and if we can stay in this rented house—even though it has no glass on its windows. What will happen to us if we can't make the rent and are forced out?

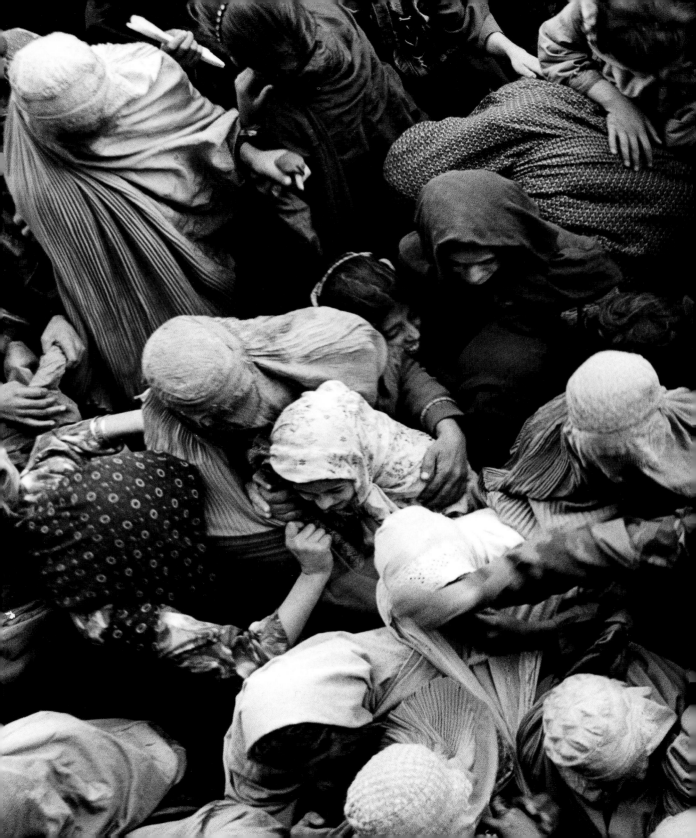

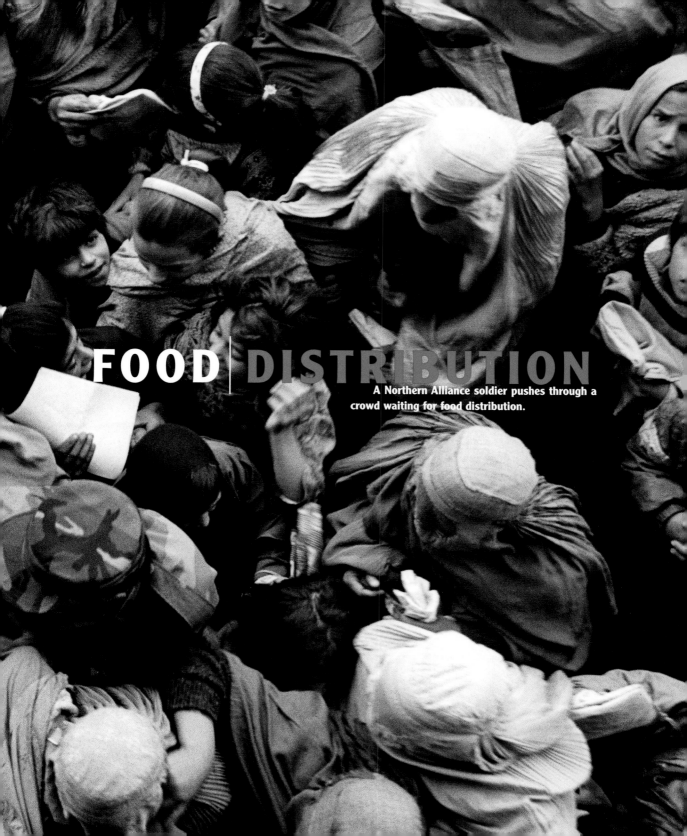

FOOD DISTRIBUTION

A Northern Alliance soldier pushes through a crowd waiting for food distribution.

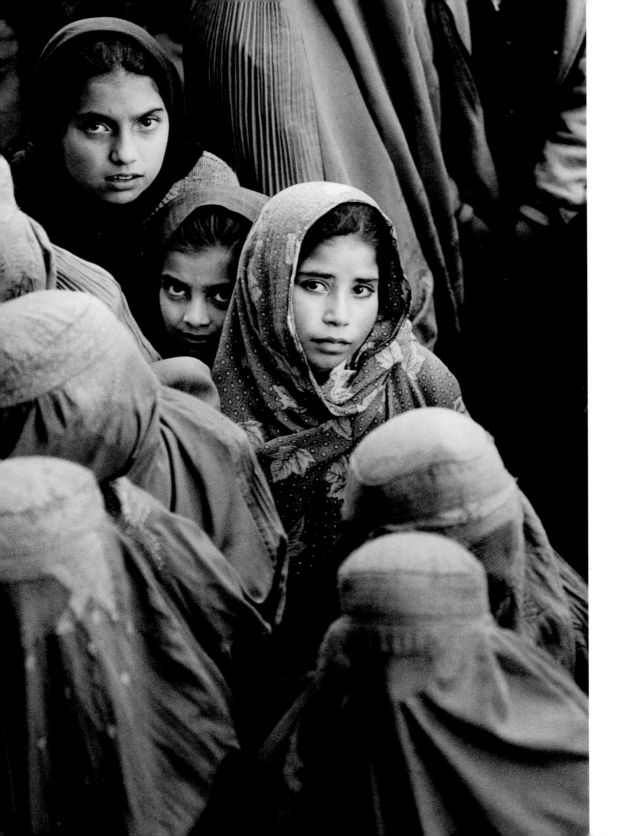

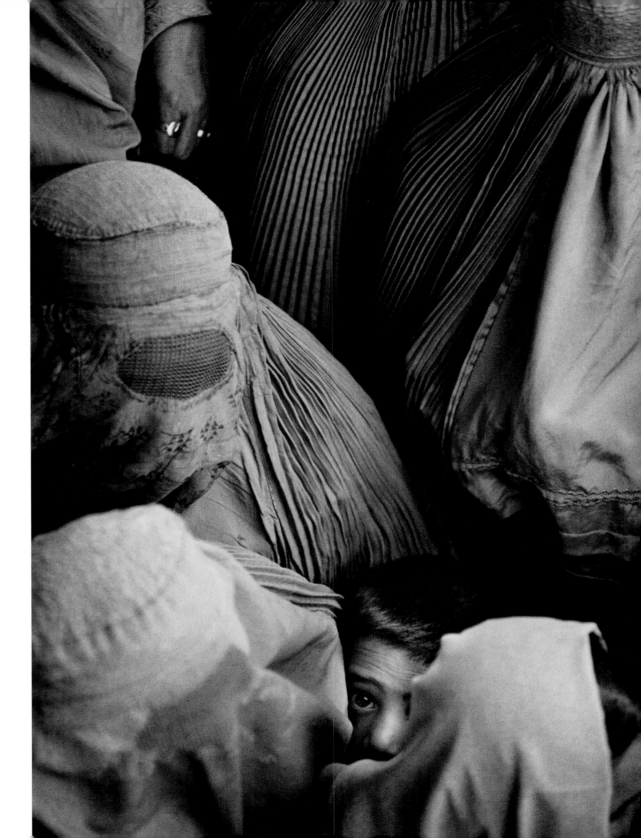

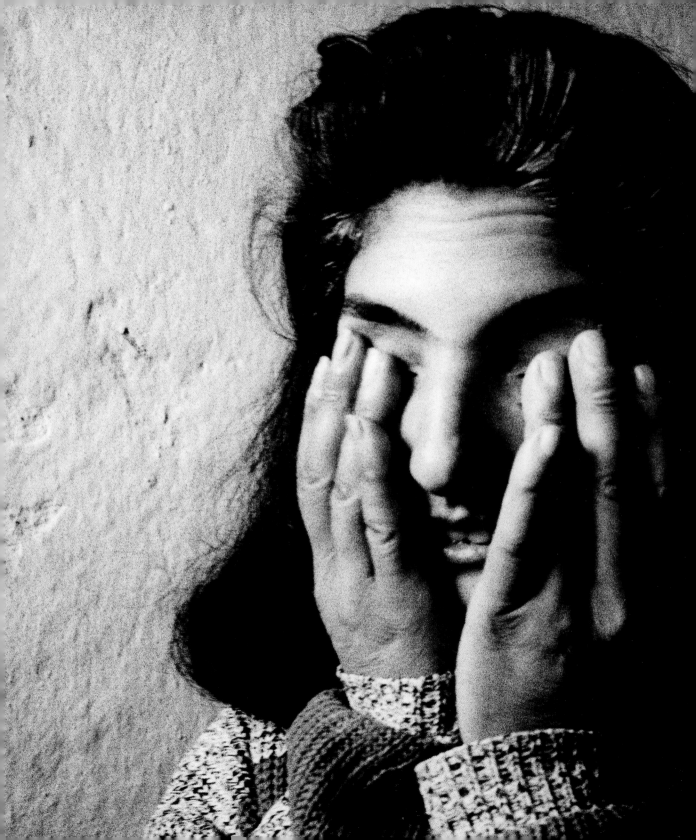

ZARGOONA

1997

I met with ZARGOONA in a freezing-cold box of a room in the house of one of her relatives. She had no heating and there was no glass in the windows. We sat underneath blankets to try to keep warm. Zargoona cried the entire time I was there.

Before the Taliban came, I taught physics in the Polytechnic. I had a good salary and a good life, and the price of living in this country is reasonable, of course. The Polytechnic provided me with three rooms in a teachers' housing block.

When the Taliban first came, I wasn't aware of what was happening because I was too busy teaching to take notice. The Taliban arrived at night, and when we woke up and saw them, it seemed like there was peace. We were happy because we thought it was good.

When the announcement came about everything we couldn't do anymore, I couldn't believe what I was hearing. Then I started to cry. I had thought that these were good people. Soon after, I went out with my young son, Bashir, to buy myself a burkha. I didn't even understand how to wear it. When I looked at the street, I couldn't see where my feet were, and I spoke so loudly I was almost shouting because I didn't think anyone could hear me! I saw one of my students on the street and he asked me to lower my voice, since everyone could hear what I was saying.

Two days after the Taliban arrived, they said that female teachers and students could not go back to our jobs or to school, but that it was okay for men. We female teachers still went ahead with writing the exams and I brought them to our students to take, but the Taliban found me and threatened, "If you come here again, we'll cut off your legs so you can't walk." I was so scared that I locked myself in a room in the Polytechnic and waited for hours to go home because I was afraid that they would follow me there.

I thought the changes were only temporary. Then my life became terrible. I had no salary and after one week, I had to leave the teachers' housing, since I no longer worked there. I had many possessions before the Taliban came, but had to sell them all, including my clothing, to buy food for my son. We came here to stay with my relative, who is like a father to me. He said he wished he didn't know me because he couldn't stand to see me like this. He is a poor man too. I was so sad at that time that I thought about killing myself. But I want to raise my son, so of course I can't do such a thing.

If I had a husband, he would work for my son and me. My boy deserves an education, but I have no money to send him to school. I want him to have clothes to wear and food to eat. The only help I get is from friends who give me what they can. But today, we have not eaten for three days. It is Ramadan and we are fasting. But even if it wasn't Ramadan, we would still be fasting because we have no food. In the evenings, everyone breaks the fast, but we don't because we have nothing to eat. I would rather kill myself than see my son starve like this. My friend suggested that I beg, but how can I? I am educated and qualified and I should be able to support myself. I am a teacher.

I don't even go to wedding parties because I can't stand my life. I have no feelings about the future; I just want the Taliban to leave. They are not human. They have no hearts, no feelings. They are jealous and illiterate and know nothing. They are like wild animals.

Everything changed completely last year and I want it all to go back to the way it was.

The rest of the world is moving forward and we are just moving back.

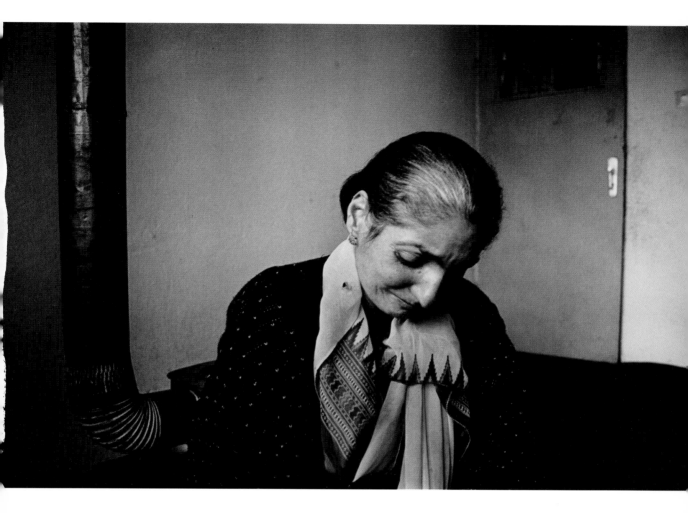

2001

Refinding **ZARGOONA** proved to be very difficult, since she had moved so many times over the past few years. When we finally found her, she was living on the ground floor of a run-down apartment block and seemed to have even less than the first time. As soon as she opened the door and saw me, she burst into tears. She had aged far more than four years. Her whole body was shaking and her hands were swollen and blue. She moved with great difficulty and had lost an enormous amount of weight.

My life is no better than when I last saw you. I am very sick now with cancer and there is something wrong with my blood. I feel stressed and exhausted all the time. I have no money at all and am forced to teach at home, but teaching just makes me more tired. I cannot cope with my life anymore. I have lumps in my breast and neck. I went to Pakistan to get some treatment in a cancer hospital. I was very sick and stayed there for seven days, but didn't have the money to continue treatment or to buy the medicine I need.

I am like a father and a mother for my only child, Bashir. My husband was killed by a rocket in the street in Kabul when I was pregnant with Bashir. In the time of the Taliban I lost my job; in the time of the mujahideen I lost my husband.

I cannot remember much of my childhood. I was born in Kabul, and my mother died when I was six months old. Being a motherless child was difficult. I lived with my aunt in a good house. I was given an education and treated well. But I have suffered so much pain in my life that I forget anything that was good. My life has been a disaster. I have nothing left from the times when I was happier. I worry so much about my son and his future. I haven't been paid for the past three months so I have no money for rent.

I used to be paid by a foreign NGO, but they have left Kabul now. I was beaten by the Taliban for teaching only three months ago. My door was not locked, as I was expecting my students that day. One of the neighbors had shown them my door. Three Talibs just walked in; two more stood outside. They were terrifying. "Why are you teaching?," they yelled. I said that I only taught the holy Koran and that they could check this with my students. But they shouted that it was forbidden to teach girls, and they started to beat me with a cable until my leg bled. They swore that if I ever taught again, they would arrest and execute me. After that, I always used a different name for teaching to protect myself. Even my students didn't know my real name. I was terrified, but I had to continue teaching

because how else could I have survived? I stopped the course for ten days, but after that I started again.

When the U.S. bombing started, many of the windows on this block were broken and most people left to go to safety. But I didn't have the money to go, and I no longer care if I live or die anyhow. Life has brought so much pain that I wanted to be killed by those American bombs. If my son were not here, I would kill myself. This life is nonsense for me. It means nothing. So why should I care about the government? Even now, there is no peace in this country. They are already fighting each other. Why should this new government be any better than the last? The Northern Alliance are no good either.

I can't even feel my hands anymore. They are constantly swollen and cold and sore. I borrow food from the shop to feed myself and Bashir. We eat mostly potatoes. Often we don't eat anything, so I'm pleased that right now is Ramadan because no one eats during the day. If there is food, I can't eat anyway, because I feel too sad.

I have no family to help me—no mother, no father, no brother, no sisters. There is only my aunt and she is so poor she can hardly support herself.

I am giving you this [a hair band] as a gift because now I know I will die.

There is nothing else to say.

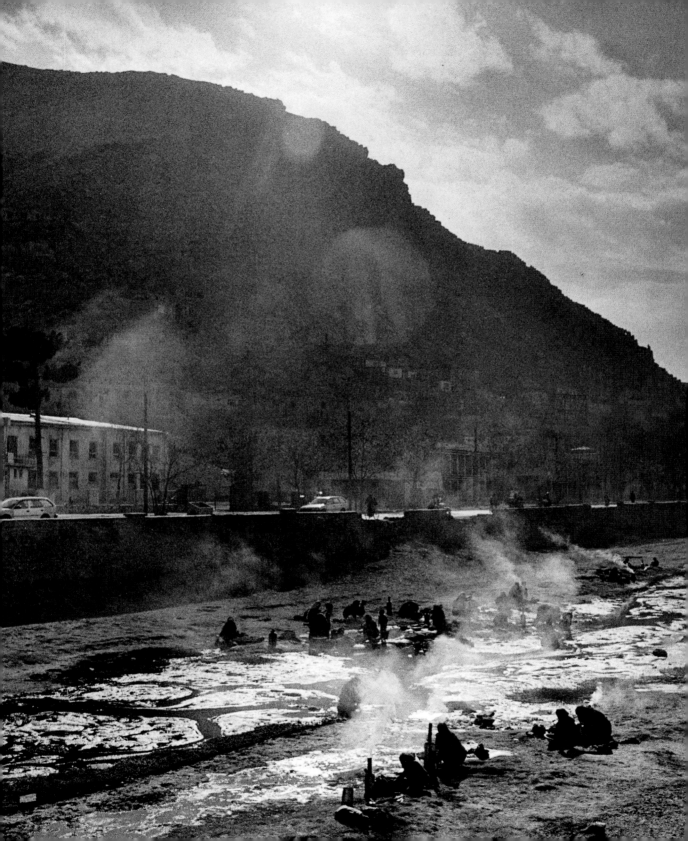

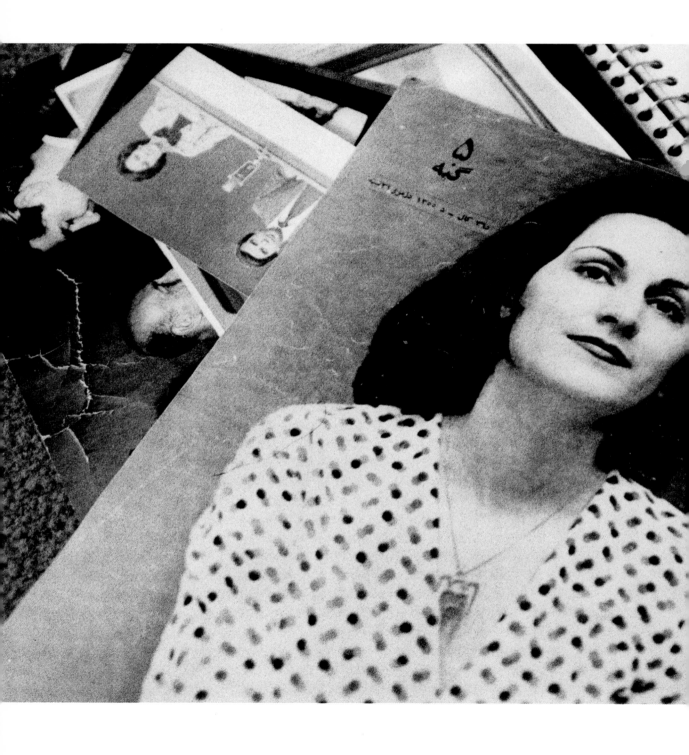

SHAFIKA HABIBI

1997

SHAFIKA was fifty-four years old and was Afghanistan's most famous woman for decades. The Taliban came to power in 1996 and fired her from her job as anchorwoman on the National Television News.

I met her and her daughter Durkhanai in Kabul in 1997, but when I returned there in 2001, Shafika had moved to Peshawar because of problems with her husband's health.

1973. As a famous television anchorwoman, Shafika Habibi was often seen on the covers of magazines.

I was a newsreader on television from the age of fifteen. My husband was educated in Paris and became a diplomat. He later worked as a government minister. We had a mansion, servants, and security guards, but when the fighting started with the Taliban, we had to abandon all of this. Of course, my husband lost his job, and now we live in the Microrayons.

These photo albums are like my obituary—they don't even seem real anymore. Look, here I am with [former president of France] Georges Pompidou.

When the Taliban came, three hundred other women at the television station and I were dismissed from our jobs. We have been at home ever since. When we were told to go home, we hoped it would not last. It felt like going back in time—as if the women were going into the shadows or being locked underground, and we did not know for how long. It is going to be a long, long struggle to restore our position.

I remember that in the early days of the regime, women were beaten for not being veiled and it seemed better to just stay indoors. I found it almost impossible to recognize my friends even if they were sitting next to me on a bus. When I get on a bus now, the conductor collects tickets and shouts at me. He doesn't know who I am. Before, they used to smile and tell the driver, "We have Shafika Habibi on our bus."

It has been so difficult for the women of Afghanistan to progress. In 1959, we were told that we no longer had to wear burkhas, and it was at that time that I started to work at the radio station in Kabul. It was a happy time: we were the first women to do such jobs. And ever since then, things continued going forward, until the time of the Taliban. I wonder if my generation went too far. In the 1970s, when the Communists took over and I went into television, our culture became almost completely European. At that time, everything here was westernized: the clothes, food, our whole lifestyle. They even showed dancing on television! But it was only here in Kabul. The rest of the country, the illiterate people, were living in another world. What's happening now is a reaction to that separation between the two worlds.

At the beginning of the mujahideen rule, I wore pants and a long coat and a scarf over my head. Men and women still worked together in the office.

A big question for me is, why don't I leave now? Most educated people in this country have gone. I think I stay because I am a religious woman. I also stay because if all of the educated women of Afghanistan left, what hope would there be for others? It is our responsibility to work with the Taliban to make things better.

I believe the destiny of everyone belongs to Allah.

My career is over now. I am not the person that I was: my brain is tired. The past is the past. Now, all I want to do is find a good way of providing some future for young girls. At the moment, they have no destiny. I have to campaign for them. If this situation goes on, we will lose a whole generation.

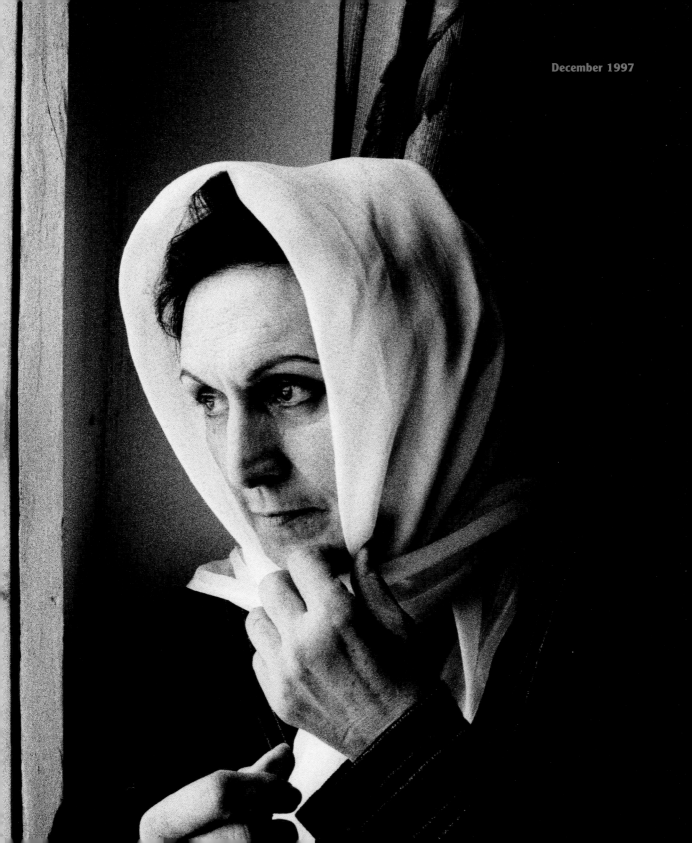

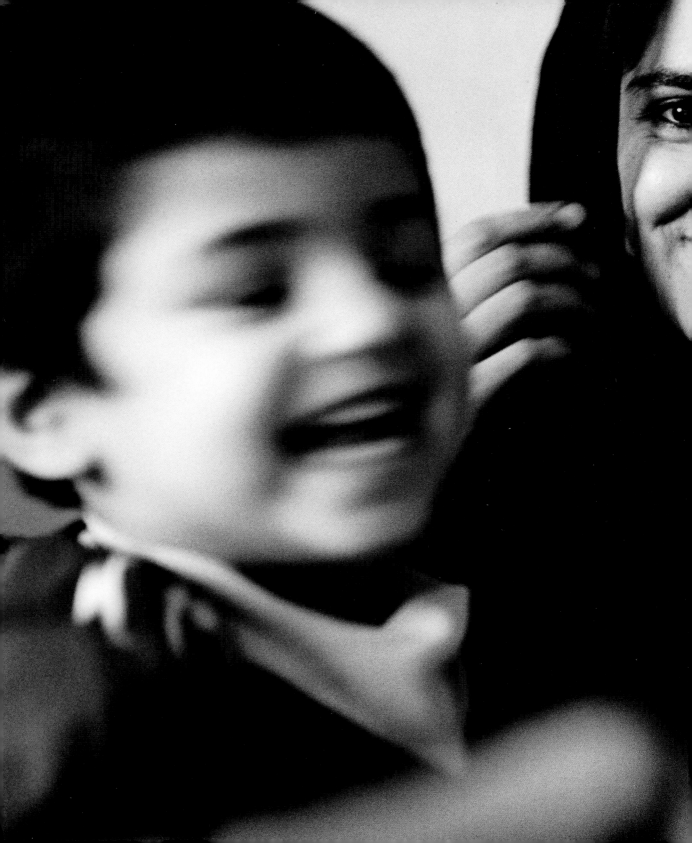

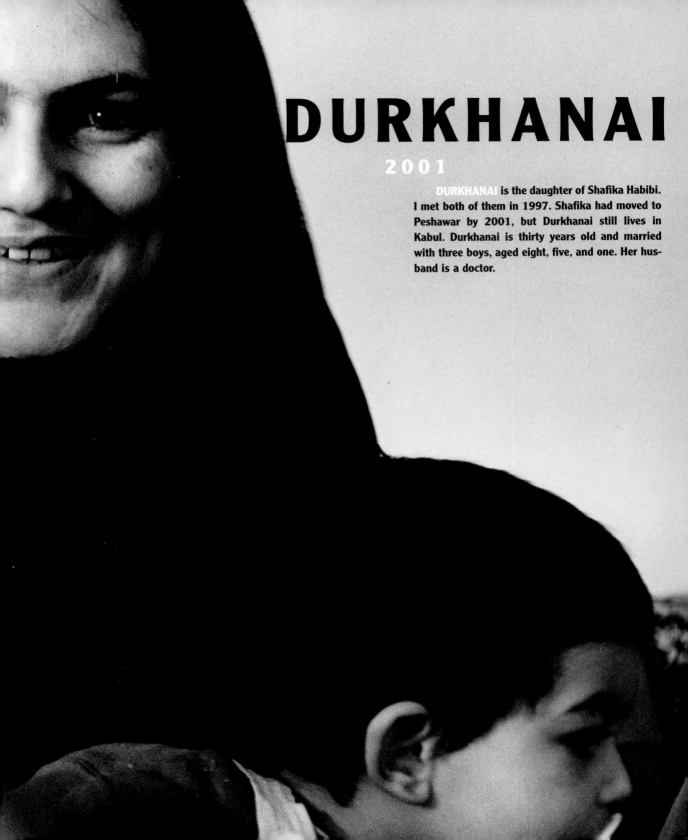

DURKHANAI

2001

DURKHANAI is the daughter of Shafika Habibi. I met both of them in 1997. Shafika had moved to Peshawar by 2001, but Durkhanai still lives in Kabul. Durkhanai is thirty years old and married with three boys, aged eight, five, and one. Her husband is a doctor.

When I was a child, we had a wonderful life. We had a nice house and a high standard of living. We traveled often around Afghanistan and had houses in other provinces. I was given a good education. My mother is very smart and my father worked as a diplomat. Kabul was very prosperous and the intellectuals here were just like Europeans.

After completing my studies at Zargoona High School, I went to Kabul University for four years and did a degree in linguistics. Education was very good then. The university facilities were excellent and our teachers were intelligent people who came from many countries around the world. Some got their teaching certification in America and Europe. There were nine departments in linguistics and I chose English. I pursued my studies successfully for four years: composition, foundation, grammar. After this the teachers there wanted me to be a professor at the university. They said that my grades were excellent. I didn't want to accept. I was very young and engaged to be married at the time. My husband-to-be felt I was too young to be teaching university students. So instead I worked as a teacher in one of the city schools after I completed my degree. I hoped I could continue teaching, but when the Taliban came five years ago, it was impossible to work. We were compelled to be at home. Sometimes I dreamt I was in front of the blackboard, but after a while, being at home became a habit and a way of life.

I was very sad during this time and even became depressed. It just seemed too harsh that they forced a woman to stay at home after sixteen years of education. What a waste.

When the Taliban first arrived in Kabul, we were at home. My husband came into the house and told us about the big change and about the public hanging of President Najibullah, and it was so shocking. Then my mother said, "Cover yourself with a big veil and let's look from the window." We saw a man down below in a black coat and a big turban; he hit a mujahideen guard with his gun. That was the first Talib I saw.

Under the Taliban, it was like a great rest for us. I studied at home—these are my books, as you can see. I am very lucky to have a mother like mine. She was a great inspiration to me. She was like our friend. She told us to study and to learn, and she helped me with my schoolbooks. My mother was a TV anchorwoman for thirty-four years. She was just fifteen when she started! While we were growing up, she told us to speak out for what we wanted. She was very political.

We stayed here under the Taliban. People would ask us, "Why do you stay here, when you can go?" My mother replied, "I stay because I want to experience the pain of my people." We could have left. We were wealthy. But she said we must stay.

It's okay to use makeup and all kinds of shoes right now, but for five years I observed the rules of the Taliban. Anyway, most of the time I was at home and I could use makeup there. I saw the Taliban hitting people on the streets to make them pray. There were men being pushed to go to the mosque.

Sometimes there was fighting in Kabul and sometimes we felt that the city was not safe. We would only wear a veil on the streets during the holy month of Ramadan—never a burkha! My husband saw the Taliban beat a young girl. She was covered completely with a veil but not with a burkha. According to Islam, only the head

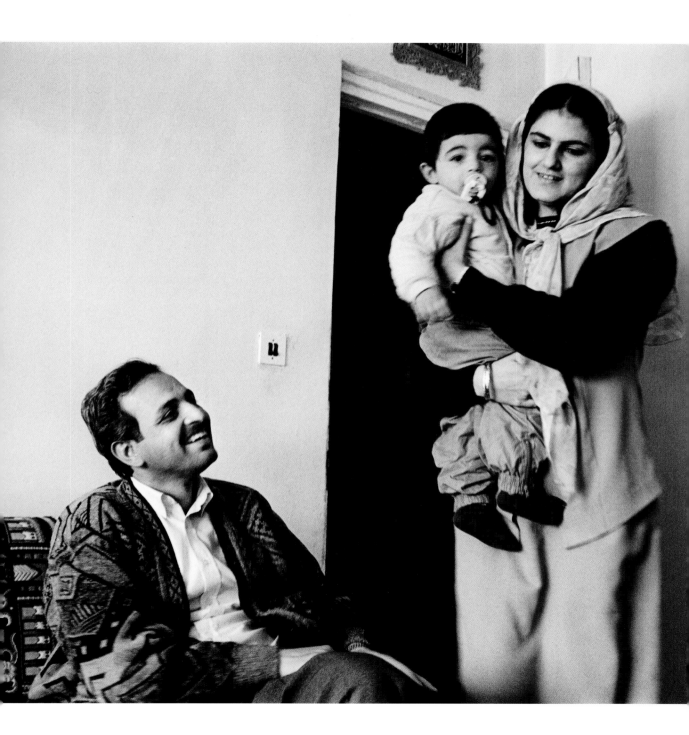

must be covered, not the face. And we were astonished by the type of Islam that the Taliban chose to follow. For us it was not Islam at all.

In these five years, people lost their courage and now they are like the walking dead with their hearts broken. It did not matter if you were educated, because we were all put in the same place. But we brought culture into my home through our satellite dishes. We kept two small ones hidden and through them we had Greece, China, India, Pakistan, France, Portugal, England, and America. We put curtains on the balcony, and the dishes were very small, and we hung tarpaulins instead of glass for the outside, and then we hung our clothes in front of the satellite dishes to hide them. We even hid them from our neighbors.

If the situation with the Taliban had continued, I would have left the country. I could not tolerate it anymore. But my husband was always sure that it would not last forever. We were like birds in a cage. For me, maybe my cage was good—my home was full of happiness. We love each other here and we are not hungry. But outside it was terrible. I thought about that all of the time, and I was depressed that I could not have a salary. My spirit was unhappy.

My dream is to stay in this country. I love my country and I want my kids to be educated here. Now that I am old enough, I want to work as a teacher in the university, and I want peace. I want my people to be calm, without anxiety for the future. We will need such a long time to rebuild this country, but it is our responsibility.

I totally trust my husband. During all of the bad times, we stayed together, all through those wars. When my parents went to Peshawar, they wanted me to go. My husband could not leave because of his job, and I could not leave him here, so I stayed with him.

The American bombing was absolutely terrifying. We live very near the airport and I was very worried for my sons. They were targeting sites all around us—the radio station, the airport, and the antiaircraft guns. The buildings were shaking, and when the American airplanes appeared in the sky, the Taliban shut off the electricity because they thought that would make America miss its targets. We listened to the radio for eighteen hours a day: BBC and Voice of America. During the last night that the Taliban were here, we listened to the radio until four-thirty in the morning when they finally left. At that moment my husband went into the bathroom and cut his beard off.

Now that the Taliban have gone, my husband has asked me to burn my burkha, but so far I have refused. Men in this country are hungry to see women, and eventually we must be strong enough to say good-bye to the burkha. But now is the holy month of Ramadan, and at this time we are more respectful; however, we hope that when Eid [the three-day celebration marking the end of Ramadan] comes, we will get rid of our burkhas.

Life has really changed a lot recently. All the people are happy and they feel freedom. We can listen to the voice of music. I turn up the cassette player very loud. On the first days after the Taliban left, my sons said, "Mother, you are playing the cassette too loud—the Taliban will come." All over Kabul, things are changing. People are selling televisions and satellite dishes on the street. Those things were forbidden before. Beauty parlors, which used to be hidden in people's homes, are now appearing on the streets. The cinema is open.

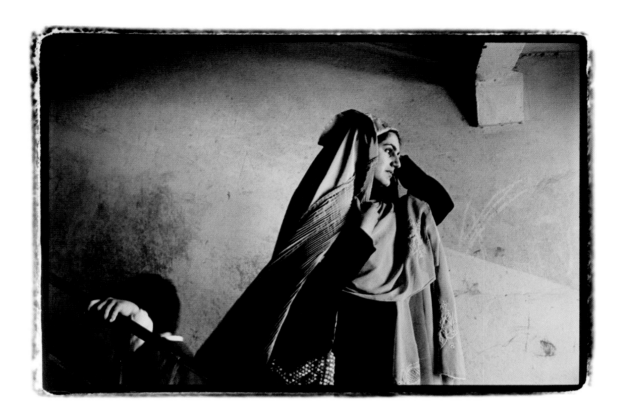

I want my children to have good health and education and the freedom to go everywhere they wish. For the past five years under the Taliban regime we did not have this kind of freedom. Sometimes my children ask me if there will be any more airplanes from Bush. I only hope that a little of my golden childhood will be possible for my sons.

I do not know who will end up running this country. I just hope for a good Muslim person, and we hope that women will be included and can play a role in the next government.

I now supervise courses in sewing in my neighbors' homes and I look after a small school. We have been running these projects for a year, even though they weren't allowed before.

I would like to ask people in other countries to listen to the voices of Afghan women. We need our rights. There are very poor people living here, and we need you to be kind to them. The men who keep fighting here in Afghanistan make me angry. I trust in Allah to make this better. It is in his hands. I think it will be fine in the future because we can't bear any more. We young men and women—this is our country, our responsibility, our future, and we stand side by side. We are like melted iron, and we are stronger now.

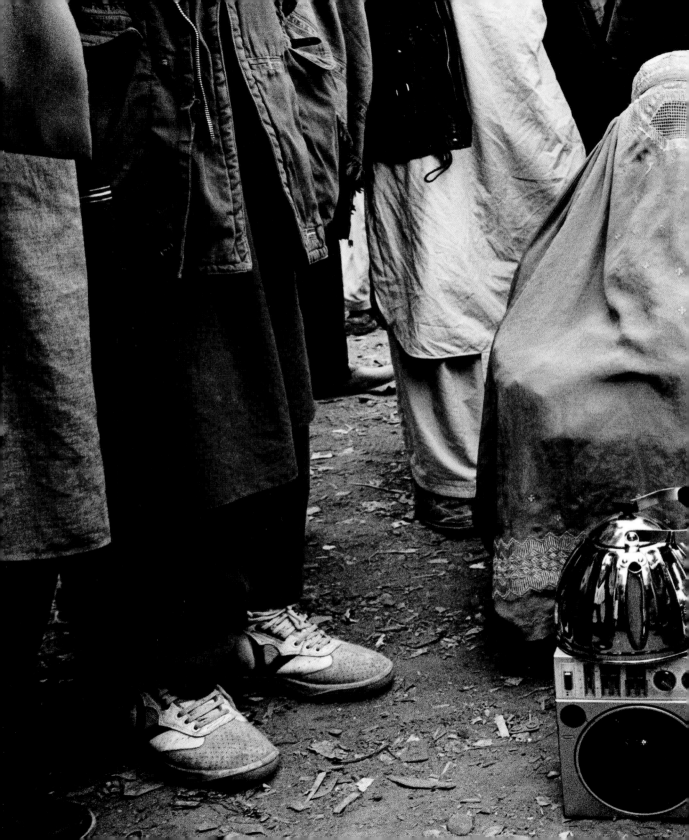

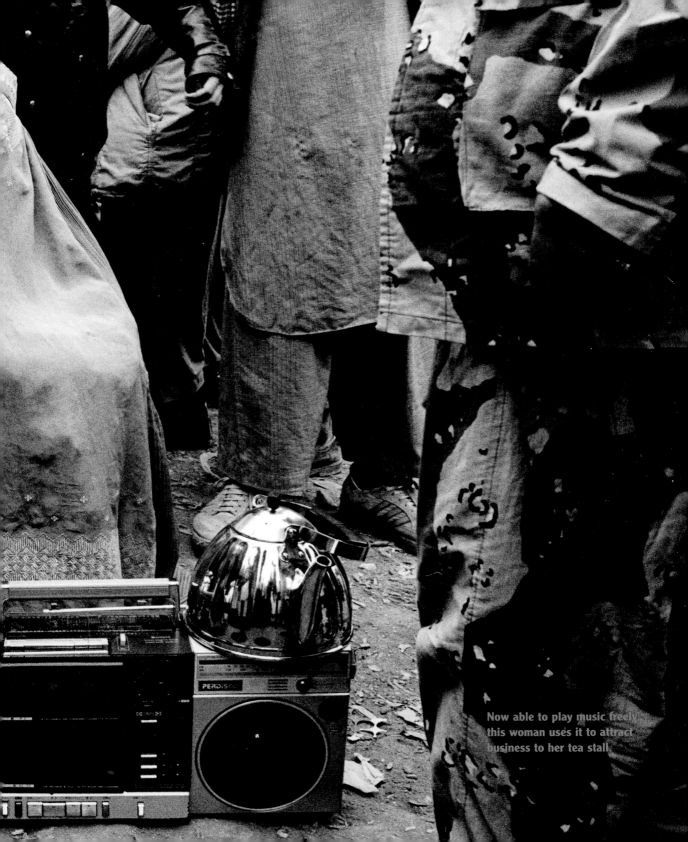

Now able to play music freely, this woman uses it to attract business to her tea stall.

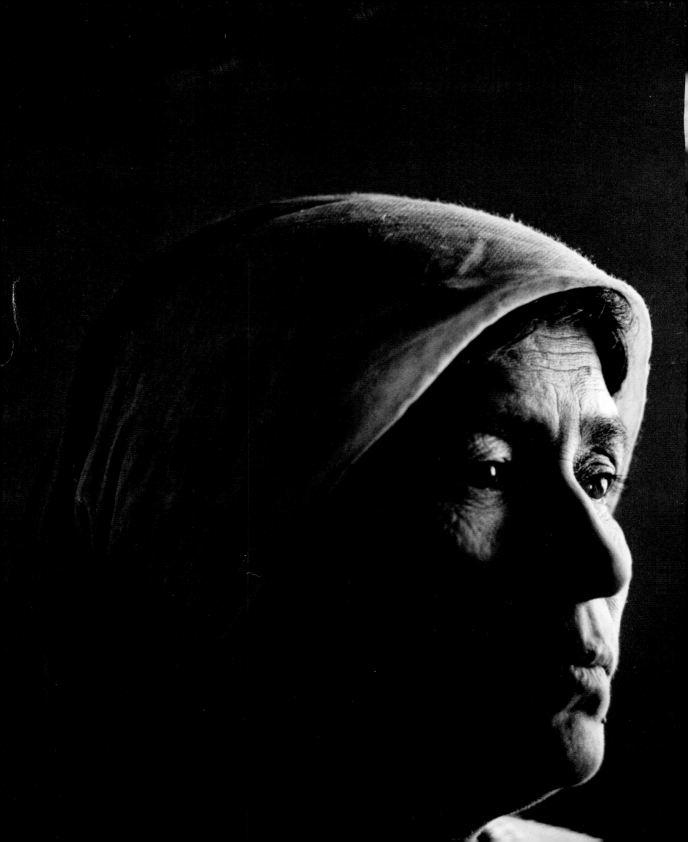

MAKY

2001

MAKY is forty years old. She is married with two boys and three girls. Maky supports herself by making burkhas. Most of their embroidery is machine-made, but the woven eye mesh must be made by hand.

I know it might seem strange to you to see this, but we make these evil things as a way to support ourselves.

The burkha has always been traditional in Afghanistan, particularly in the provinces. Kabul is the only place where women stopped wearing it. So even if the women of Kabul stop wearing burkhas again, there will still be a big demand for them in other parts of the country.

There is also a need for burkhas to be exported to the Afghans who live in Pakistan as refugees.

My husband does what he can to help support our family. He is a good husband and a kind man. I have been married for twenty-two years.

My husband is very good at hugging me.

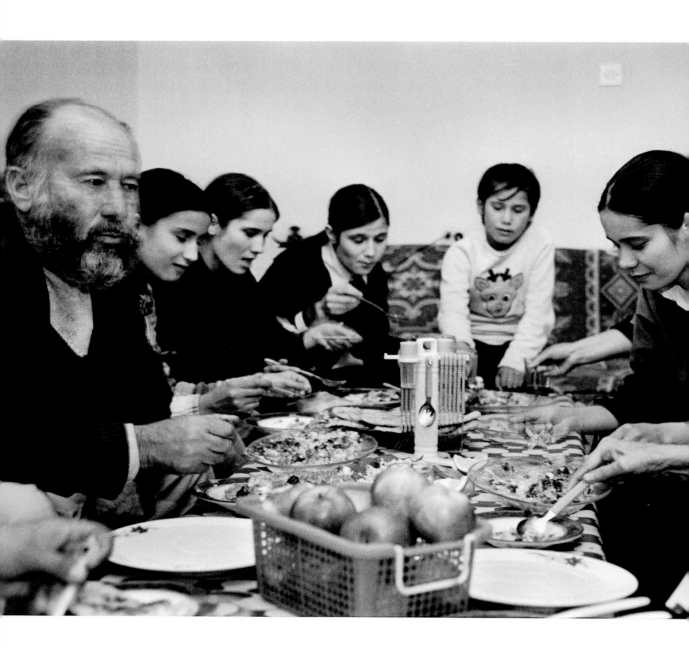

KHANEMGUL

2001

KHANEMGUL is sixty-nine and has six daughters and three sons. One of her sons died, and his wife and their children now live with her. She has two daughters still living in this house. In total, there are nine women and four men living here.

I remember the time of King Zahir Shah. Schools were open then and everything worked. Our lives were good. I remember the first time that women removed their burkhas. The government gathered women from all areas and told them that they could show their faces. That was in 1959. I was living in Helmand, near Kandahar.

I remember my childhood here in Kabul. My father worked in one of the palaces. Kabul was very beautiful. There were many intellectuals and it was a happy place to live. There were fine buildings here. There were museums with sculptures and antiques. And there were beautiful gardens full of plants. In the zoo, there were interesting animals. We would go to the gardens and the river; women went for picnics in the park.

When I see Kabul now, it fills me with pain and sickness. I am just getting old in this destroyed city. My grandchildren are illiterate. What hope is there for them? They just play with dirt outside the house. They have no education, and our life is bad. At night, I don't sleep, due to terrible anxiety for their futures. When I think of the past, I remember the city as a beautiful one and I can't believe what has become of it.

My grandchild cannot answer your questions when you talk to her. She can't understand what you are asking her. This is the legacy of the Taliban. She is deprived of education and of the ability to think properly. The children have all missed five years of education. If they work hard, maybe they can make this up.

Her grandchildren have this to say: Homa, sixteen years old: "I will do my best to make this up"; Salma, fourteen: "I want to be a flight attendant or a doctor"; Soma, thirteen: "I want to be a journalist"; Arezo, eleven: "I want to be a journalist"; Sona, eight: "I want to complete my education and become a teacher."

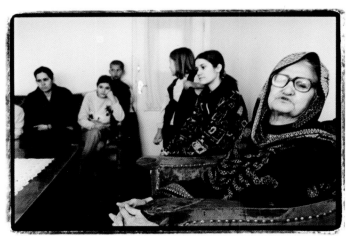

Khanemgul

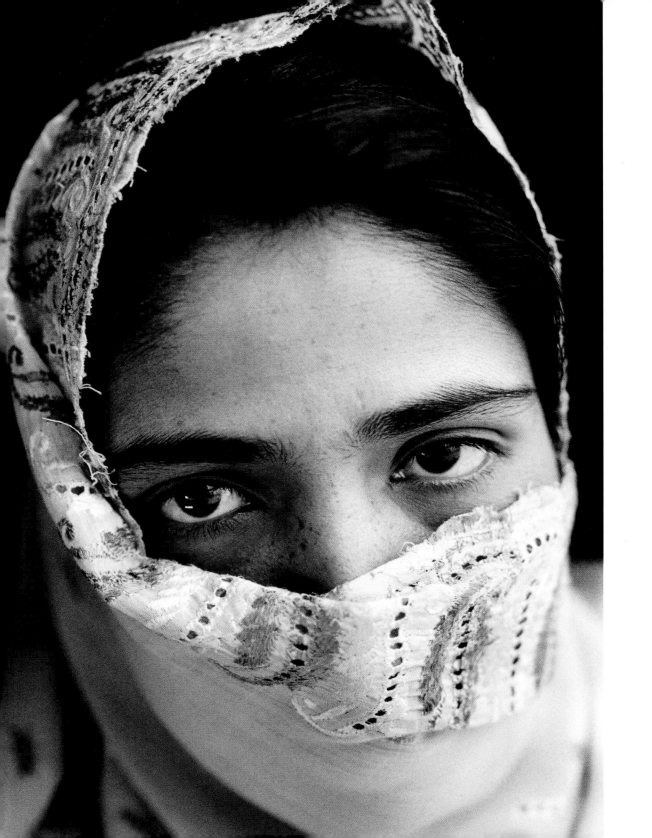

PALWASHA

2001

PALWASHA is twenty-six years old. I met her in Peshawar at Mary MacMakin's house. As we spoke, U.S. fighter planes were flying overhead on bombing raids to Kandahar.

I have worked with PARSA since 1997. I came here from Jalalabad. When I was younger, I lived in Kabul with my mother, father, two sisters, and two brothers. My father worked as a military police officer until the mujahideen came to Kabul. Under the mujahideen, we couldn't move freely because different commanders controlled different areas. Once, they took my brother to prison and beat him very hard because our home was in a Hazara area. But we are Pashtun!

The Taliban took control of other provinces before they came to Kabul. They killed many people in other places, and we were frightened that this would happen in Kabul. They did, of course, just as we feared they would. Before they came, I had taught first grade in the local school. I was so upset about having to stop my

classes that I didn't sleep well at night. I wanted to be a good person, to help my society, and teaching was a way for me to do that.

In August 2000, I left Kabul after being imprisoned. One day, the Taliban came to the PARSA office while we women were in the bathroom. We were preparing to pray when we heard the noises. They pushed the door to the bathroom. I said, "There are women in here, what do you want?" They said, "Come out now!" "But we don't have our burkhas on," we told them. They asked where our burkhas were, and went out and got them, and told us to put them on. We were very frightened because there was no reason for them to be there.

They told us to leave the office. We refused, and they started to beat us with their guns. There were eight women there—four of us were beaten. I asked them, "Why do you come here?" They replied, "Because you teach Christianity." There was a Koran in the office, but there were also many magazines—from America—about sewing. The Talibs said, "Look at the women in these magazines. They wear no burkhas. You deceive us by putting the Koran in here." They were so ignorant that they thought our laptop computer was a television!

Finally, they got us downstairs and told us to get into their cars. We said, "We have our own cars and won't get into yours. If you want us to go anywhere, we're going to travel in our own cars." They accepted that, but one Talib sat in each car with us. They tried to stop Mary from getting in our car, but she started to shout at them that if they took us, they must take her, too. They beat her with a whip and threw her into one of the cars with us. About fifty Talibs had surrounded the office. They said that Mary was a spy who had converted us to Christianity and made us teach it.

The Talibs took us to prison and pushed us into a little yard. There were many other women there, and it smelled terrible. I thought, how will we endure this? I was so nervous. I asked, "Why have you brought us here? We haven't done anything wrong." They replied, "You are working, when you should sit in your homes and wait for Allah to drop food to you." They said that we were not Muslims and that if we had faith, then Allah would drop food into our homes: "You can have Allah for bread to eat. Go and tell Mullah Omar what you're saying. Don't talk to me. You are an atheist."

We spent four days and three nights in prison. After two days they told Mary that she was free, but she refused to leave and said she would not go until they freed her staff. They then said, "You have no right to live in Afghanistan, and we are giving you twenty-four hours to leave the country." Some American people came to the prison and told them to release us. That bothered the Taliban, and after four days, they told us to go. The news of Mary's arrest had spread to other countries, and the Talibs were worried about international pressure.

We were very happy to be free finally, but Mary had to leave immediately. She was only given enough time to collect a few possessions before leaving Kabul. One week later, I also left. The Taliban had our home addresses and we were scared about what might happen. At that time, it was easy to move between Afghanistan and Pakistan; they didn't even ask to see your passport. You just sat in the bus and crossed the border. So that's what I did.

After four months of living in Pakistan, I returned to Kabul. I worked secretly there on some of PARSA's carpet projects. I was at my home in Kabul when the bombing started, and we were thrilled. We thought, "Two to three

days, and the Taliban will be defeated." We were frightened at first, of course, but then we saw that the Americans were hitting their targets. We listened to the BBC and other news programs so that we knew what was going on during that time. We heard people say on the radio, "Don't be frightened." They said they had to fight the Taliban, but that they didn't want to hurt us.

We don't want this guest, Osama bin Laden, in Afghanistan. We feel that the Taliban are terrorists for bringing him to our country. If I could, I would kill the Taliban and bin Laden.

No one was angry at America. We wanted their help. But after some days, when they hit people's homes, we felt angry, because none of this was our fault. I stayed for one month during the bombings because it became very hard to leave.

Finally, four of my family members and I decided to go. At four-thirty in the morning, we left Kabul and headed to Torkham by bus. There were many people on it who also wanted to get out of Afghanistan. We were frightened near Jalalabad because the Americans had been bombing there. The bus driver said, "Let's go quickly so we don't get killed." When we arrived, we saw that the border gates were closed, and we had to turn back. Things had gone smoothly until then! We all rode back to the bottom of the mountain to a smugglers' route. We left the buses there and started to walk. One member of our group couldn't walk, so we took a donkey for her. My brother took my hand and pulled me up the mountain, which was very steep. It was three in the afternoon, and there were many people crossing that mountain. We had to walk for several hours

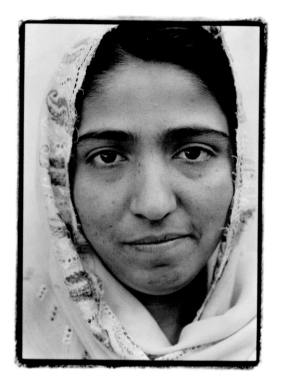

over the mountain to safety. Then we found a bus to take us here to Peshawar.

My first desire is for peace in Afghanistan. I can't imagine an Afghanistan that is peaceful. Not even in my dreams. That could only be possible if America wanted to help us and if the world does not forget us like before.

My message to women is to think first about the important problems, which are getting an education and working for a living. They should not think of luxury and fashion. Our country is poor now, and Afghanistan needs women to help rebuild.

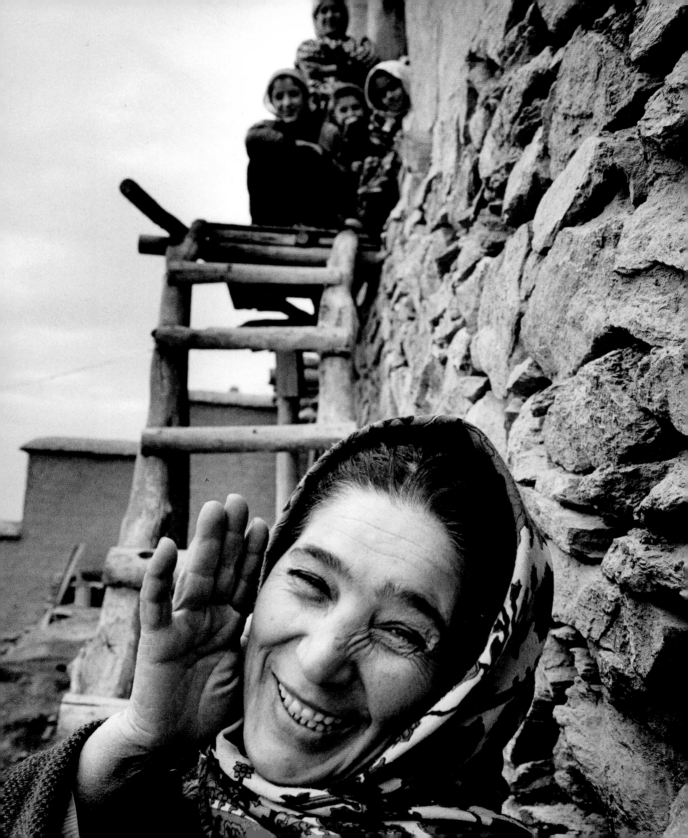

HAMIDA

2001

HAMIDA is forty-three and used to work as a tailor and a carpet maker. She has five children.

Before my husband died eleven years ago, I worked at home as a tailor for people who lived locally. My husband was a high-level government official, and in those days, we lived well. We lived here in this house, my children were students, and our lives were fine. Now I have two boys and three girls to support on my own.

I worked for CARE [an American nongovernmental organization] for seven months before the Taliban arrived. The job included making clothes, embroidery, and teaching sewing to girls. Seventeen days after the Taliban came, they closed the project down and sent an American woman from CARE to our houses to remove our sewing machines. She was upset and said she didn't know what was happening or if we would meet again in the future. I felt so unhappy. I went back to tailoring and also made food which my sons sold in the bazaar: *pacora* [potatoes and meat wrapped in soft bread] and *burlani* [leeks and spinach wrapped in soft bread]. I was very angry that the Taliban had stopped me from working. Nowadays, I make about twenty dollars a month. With it, I support my family, but it is very little money to survive on.

One day, I went to the bazaar to buy some flour. A big crowd of people was standing near the shop, including a large number of men. Suddenly some Talibs came and beat me on my back and legs. They cut me badly with their whips. The thrashing lasted about two or three minutes. "Why are you standing with these

Hamida in 1977

men?," they were shouting. "You don't know them!" I tried to explain that I was just trying to buy flour, but they pretended not to know what I was saying, even though they obviously understood Dari. I have this scar on my leg as a memory of that day. Another day, I saw some Talibs beating a very young boy for carrying a radio. I picked up a stone and yelled, "Stop hurting that boy—he's too young!" One of those wild men picked up a big rock and threw it right at me. It missed me but hit my neighbor in the face. She was bleeding all over the place.

I asked for asylum from Denmark and Sweden, but they both rejected me. Now that there is no Taliban, however, I will stay in my country. I have faith that things will get better now that they have gone.

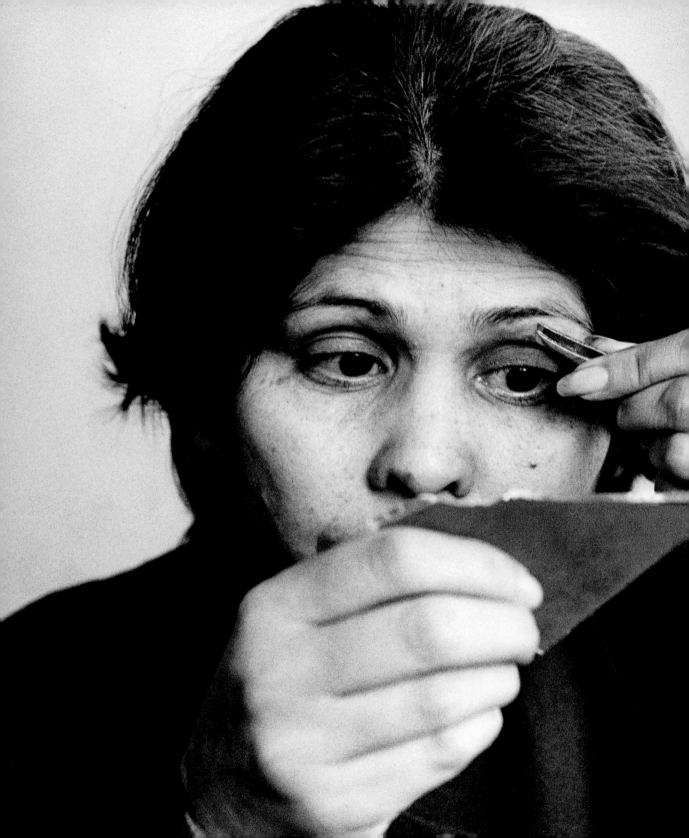

ANISA

2001

ANISA is thirty years old and was a high-school teacher. She lives in the Microrayons in Kabul with her second husband and six children: five boys and one girl. Anisa has a very strong presence; she talked immediately of how she was intent on throwing her burkha away. She had already gone to the market to buy a veil to wear out in the streets instead.

The first time I visited her apartment, she showed me old photographs of herself. During my second visit, she sat plucking her eyebrows while we talked.

I am very pleased to meet you.

I was born and educated in Kabul. My childhood was happy. Kabul was amazing at that time, and there was so much to do. We could go to concerts, the cinema and restaurants.

It was a beautiful city with universities, parks, and fine buildings. Our lives were as good as yours.

I felt like a Western woman during Communist rule in the 1980s. We in Kabul could do everything, just like the women in your country. When I look at these old pictures, I can't believe I could wear the clothes I wore in those days—dresses, short skirts, and tight T-shirts. When my kids look at those pictures, they can't believe that it's their mother! It has been ten years since I have worn such things.

During the Russian invasion, there was fighting in the rest of the country, but not in Kabul. At that time, I lost my first husband. He was an officer during the Communist regime—a very political man. He was killed in Jalalabad. I married his brother a year after his death. My second husband works as a de-miner for Halo. He has done this for the past three years, and I worry constantly about his safety.

When the mujahideen took control of Kabul, I was very unhappy. They made us wear a veil and were much more strict about what we could wear than the Communists had been. I was used to the Western clothes I had been wearing, and I felt strange having to wear a veil all of a sudden. I didn't take the *hejab* [veil] seriously during the time of the mujahideen; I just kept it around my neck like a scarf. But they weren't so strict about us covering our heads. We couldn't

show our legs, but we wore tight clothes and could show our bodies that way. The problem is that we didn't feel safe during the time of the mujahideen. There were many robberies, and women were raped by these soldiers. Kabul became lawless, and we lived in fear of what might happen to us.

Some armed men came to take away one girl who lived here in the Microrayons because they wanted her. They had seen her in the street and then found out where she lived. But instead of going with them, the girl threw herself out of a window on the sixth floor of a building and killed herself. We heard about some really disturbing events like that, but otherwise, life was okay. Girls were going to school like normal.

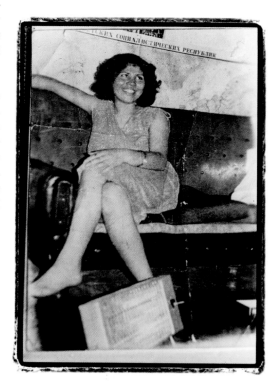

Anisa in 1988

Of course, there was fighting in and around Kabul. Even here in the Microrayons, different factions of the mujahideen fought each other. They were always fighting. But soon, that became normal to us and we found out how to adapt our lives around it. It was dangerous living in this city. Rockets landed all over it.

Gradually, the destruction that you see now began to happen. I was so upset when it started. The city began to fall down. Buildings were damaged, and of course, we stopped thinking about cinemas, restaurants—all of these things. We only thought about the lives of our families. We didn't have the money to leave the country, so we stayed. It is incredible how quickly a city can be reduced to ruins.

Before the Taliban came, we thought they were the people of King Zahir Shah and that they would be fine and good. But they came with their long beards and black turbans and killed President Najibullah and all of these other mujahideen. I didn't even own a burkha, so I had to borrow one from a neighbor to go to the bazaar and buy my own. Many other women

there were cursing the Talibs and buying these ridiculous and restrictive things for the first time. I felt so uneasy wearing it and still do today. Wearing it gives me a headache because it's so tight on my head.

One day, as I was walking along the street, one of my pant legs had risen up a little. I didn't notice, but a Talib did and ran over to me and started to beat me with a whip. I hadn't even realized that my legs were showing! It was humiliating and frightening.

This is my only girl, Sarah. She's one and a half years old. I hope she'll be lucky and never know or remember these bad times. She is so young. I hope she'll have an education and the right to have a free and good life.

I don't feel confident about the future. There have been so many changes over the past years. Each time I started to feel happy, things got worse, so I can't get my hopes up this time. I have gotten used to the failure of this country to make things better.

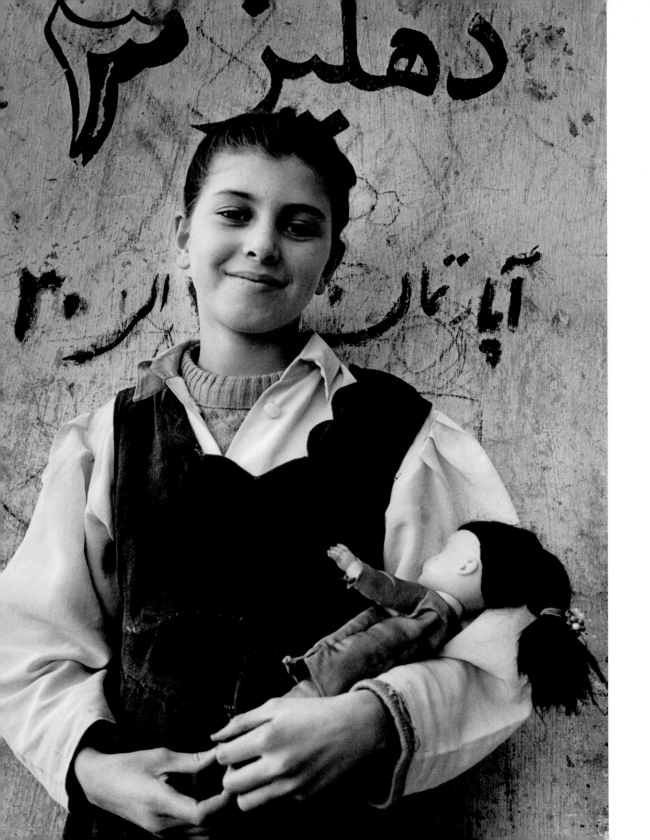

SANAM

2001

My name is Sanam and my doll with the black hair is Sadaf. I am nine years old.

Now I can walk around with my doll with no fear, but only one month ago, when the Taliban were here, I had to hide my doll behind my back because if they had found her, they would have beaten me.

I can carry my doll freely now and I am very happy about this.

I want to be able to go back to school now that the Taliban have gone, and when I finish school I want to be a doctor.

My other doll is called Solhaila, but my favorite doll is my new one—I haven't given her a name yet because I only got her last week on Thursday as a gift from my uncle.

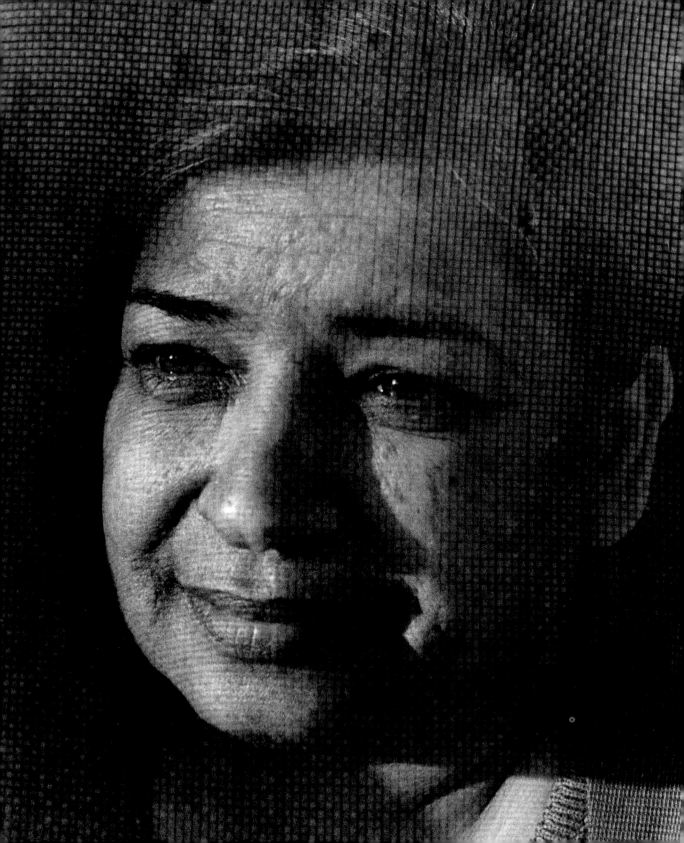

LATIFA

2001

LATIFA is forty-seven years old and lives with her husband and six children.

I lost my foot during the war. I stepped on a mine about ten years ago, when I was thirty-seven. I was walking through the street in a mined area but I didn't know it, and the mine exploded and I lost my foot. I found it very difficult to wear a burkha because of my handicap. And so, in five years of Taliban rule, I only left my house four times. My husband had to go to the bazaar to buy what we needed. I only left my house those few times to buy underwear—the one thing my husband could not buy for me. On those four occasions, I wore only a veil, not a burkha, and I felt paralyzed with fear of what might happen to me.

I completed a degree in law at university and worked in the Ministry of Justice before we were forbidden to work. At home, I couldn't do anything. I was bored and frustrated. What a terrible waste of my education! Two days ago, I went back to sign up for work again as a lawyer.

I am so angry with the Taliban—they were the cruelest of them all in these long years of fighting. They beat one of my daughters very badly. The Taliban were distributing food at the time, and in the rush, my daughter was hit in the face and her nose was broken.

The Taliban should not be in the new government—they are like a tourist group. The Taliban is full of Arabs, Chechens, and Pakistanis—not Afghan people—so why should they be in the new government? We are happy for the help of the United States in destroying the Taliban and in bringing peace to Afghanistan. We think the United States should have a role in rebuilding our new government.

I ask that the new government take into account that we women are much more than half of the community. We deserve our rights. I want a broad-based government. Afghan people suffer too much pain, and the new government should be free from discrimination among the different tribes. They must share power equally.

To women across the world: Please help us Afghan women. We have just come from a dark period into the sunshine. Please do not forget that we are here. Learn from us so that what we have suffered will never happen again.

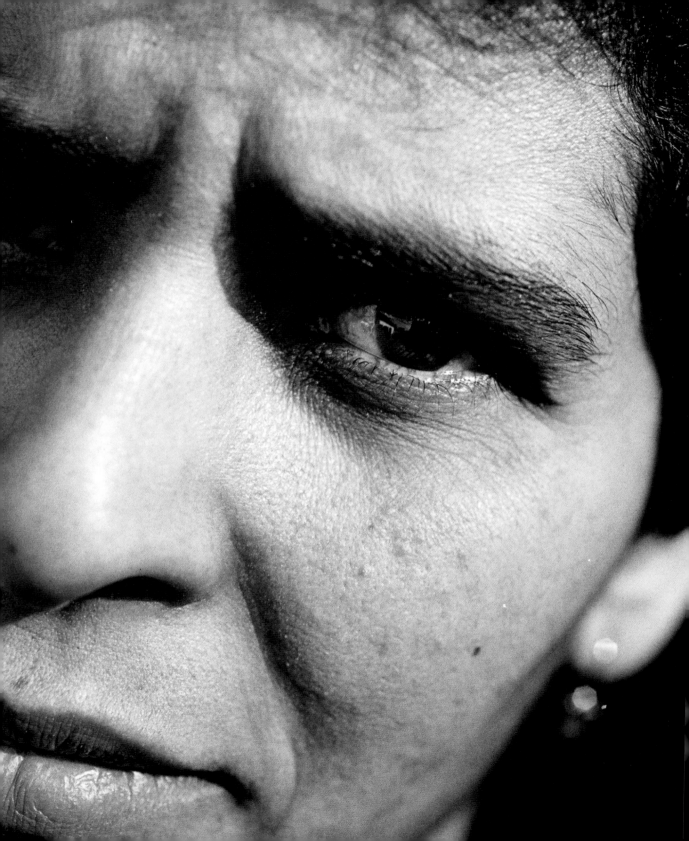

NAHED

2001

NAHED is thirty-two years old. I interviewed her in Peshawar. She is a teacher and supervisor for home schools in Kabul.

I remember only bombing and fighting from when I was a little girl. I had a normal education, except that it was hard to study sometimes, when we did not have electricity. I completed my education in the department of literature at Kabul University. I had to wear braces on my legs while growing up. When I went to university, I was worried that people would laugh at me, so I gave them up. But now, my legs and back give me trouble, especially when I work hard. Of course, it's difficult to get a good doctor to treat me nowadays.

When I was at university, I wore pants and shirts and shoes just like you do. I like your shoes very much. I remember wearing shoes like that.

Before the Taliban came, men in Afghanistan claimed that they gave women their rights, but it was not a reality. It is our tradition that men never allow women to have equal rights. It won't change now—even our educated men have an agenda. And even if they let women work or play a part in the government, the situation in our homes will be the same. In Afghanistan, women are considered the property of men. Our husbands and our fathers have the right to prevent girls from going to school or doing other things. Women must work in the home as well as outside of it. The men expect their wives and daughters to do everything for them. And if something goes wrong, the man is entitled to beat them. There is nothing we can do about this. It is normal here. We have all been beaten at home: my brothers beat me many times. And for that, I hate men and I never want to get married.

Recently, I have been employed by PARSA as a supervisor for their schools. They run forty-one schools, where between seven hundred and eight hundred girls are being educated! The Taliban found many of the secret schools run in teachers' homes and shut them down. I took the risk of teaching because my father was dead and I didn't want my mother to have to risk working. Life was very difficult. Kabul was like a prison, and I just wanted to get out and live somewhere else—somewhere where I was free to work and study.

One day, I was on a bus which had curtains over the women's section. All of the women inside, including me, had opened their faces [lifted their burkhas]. The Vice and Virtue police had somehow seen us, even though there were curtains, and they got on and beat us all with hard sticks. It was their job to beat women who did something wrong.

I don't want the Taliban to exist anymore. But it's not that simple. Twenty-three years of fighting. We have lost all the basic things—education, economy, infrastructure—they're all gone. Everyone has lost friends and family.

I feel really saddened by all of this. Once, we had a country that we hoped would be one of the best in the world. But now, we must start from zero again. I am one of the women who want to work and share in the rebuilding of my country, side by side with the men.

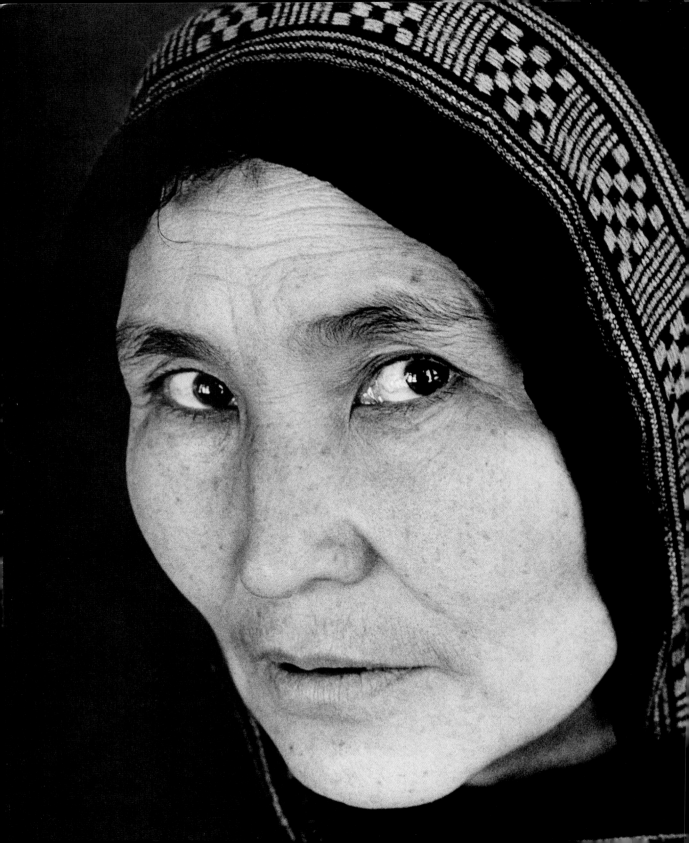

SHAMA

When I came into this Hazara household, the women there were hesitant to tell me their names. For many years, members of the Hazara tribe, a minority in Afghanistan, have been persecuted, and they are now distrustful of any outsiders.

The Taliban were very much against us [members of the Hazara tribe]. They didn't want us to live freely in Afghanistan. They just wanted their Pashtun people to live here. But 10 percent of the population are Hazara, and we have always been in this country. My family has lived in Kabul for fifty years. All our children have been brought up here. My husband is a driver and he supports the family. But there is no good work here.

The discrimination against us has been constant. Many of our Hazara friends and neighbors had bad experiences, especially over the past five years. Every Hazara household had members of the Taliban enter their homes. They put many Hazara men in jail. Many Hazara women were raped by Taliban. When their men tried to stop that from happening, they were beaten, and some were killed.

For five years, we've had Talibs coming to rob us, raping our women, killing our men. So now, we are happy that they have gone, of course. But it's still very hard for us to feel that we're an accepted part of this country. All Afghan people should be the same now. We have lived around Pashtun people and around people from Kandahar; in the past, this was never a problem. The Taliban made us feel that we were a problem, and we fear that the Taliban may still come back.

You have to understand the things that have been done to us. There have been massacres, like the one that happened at Dasht-e-Leili, where they killed hundreds of people.

Allah gave me these children. I worry about them so—the boys and the girls—and I worried about what the Taliban would do to them. My son was imprisoned in Kandahar. They came to our house and arrested him for no reason. He spent seven months in jail. During that time, he was beaten and electrocuted. One time, he was not fed for twelve days in a row. Now he just lies in bed at home and can do nothing.

When the bombs started falling, we were really happy, even when we heard the sound of them nearby. We knew this meant the end of the Taliban. And this was the end of our pain. So we were not frightened at all.

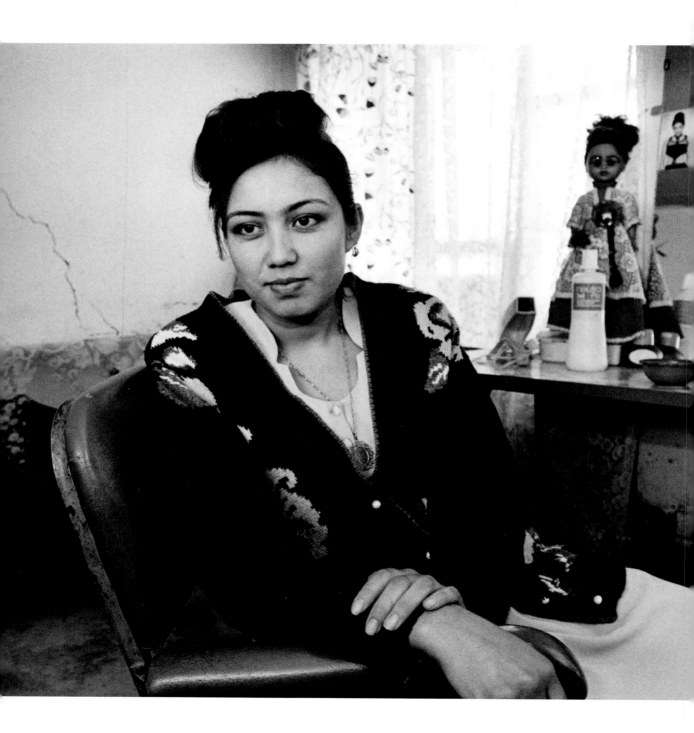

LAILA

LAILA is nineteen years old. She is a hair-dresser. Her salon is a room inside her heavily gated house.

Several women came to have their hair cut by Laila as we talked to her. They all agreed to be photographed, but five minutes after one of them left, she reappeared, visibly frightened. Her brother was very angry when he found out she allowed a Westerner to photograph her. She was afraid of what her husband would do if he found out, so we gave her a blank roll of film to satisfy her brother and to keep him from informing her husband. We promised that her pictures will not be used. She was apologetic and embarrassed and said, "The Taliban have gone, but many of our husbands are worse."

When the mujahideen were here, I took a course here in Kabul to learn how to be a hairdresser. I was very young and eager to learn how to do the work. From the time I was a little girl, all I wanted to do was cut and style hair. There used to be a hairdresser near my home and I would watch the brides get their hair cut there. They always looked so beautiful afterward, and I became determined that one day I would learn these skills.

I became very unhappy when the Taliban were here because I was unable to work freely. I cut women's hair here, inside my home. In a way, we could work normally, even though we were afraid of what would happen if we got caught. A woman was working as a hairdresser in Kabul and the Taliban found out and beat her and her husband. After that, they went to live in Pakistan.

We opened this shop in 1995, and it has always looked pretty much the same, except that in those days, we did not have these Indian pictures. You won't believe this, but the Taliban brought their women here! They banned us from working and then expected us to cut their wives' hair! It's the same with everything—they also banned music and then listened to it. I just don't understand the way these men thought or acted. It is a mystery to try to understand the reasons for their actions. At first we didn't realize that these were the women of the Taliban. But then the women said, "If you have problems with Talibs, tell us and we can help." These women had money, and you know what? They

would walk to their cars without burkhas, wearing only small veils. They could do things we didn't dream of.

My ambition is to continue with this job. I am married with one daughter of two and a half years. My husband earns good money as a draper. He is pleased that I'm doing what I love, and he supports me. I have been married for three and a half years. Many young girls got married during the time of the Taliban. Being at home became their way of life. Forget careers; they just moved backward. My family wanted me to get married. My husband is twenty-five years old and he's kind. I have friends with husbands who only hold them back. That's just insecurity. My husband isn't like that.

I would really like to travel abroad. I want to go to Western countries like America. I am not interested in these Asian countries—I don't want to go to Iran or Pakistan. America is an advanced country, and people there have freedom. The people there are very educated, and it's a beautiful country. I've heard American music but don't understand what they're saying. I don't have any cassettes anymore. I watch movies from America, like *Titanic* and *Rambo*. We watch a little American television on our satellite. I have relatives who have gone to live in America, but we don't hear from them anymore. I think that they're having such a good time there that they have forgotten us here in Afghanistan.

I bet that when schools and offices start properly, women will stop wearing their burkhas. The women here want to look more glamorous. They come here and look at the photographs of Indian women we have, and they ask me to

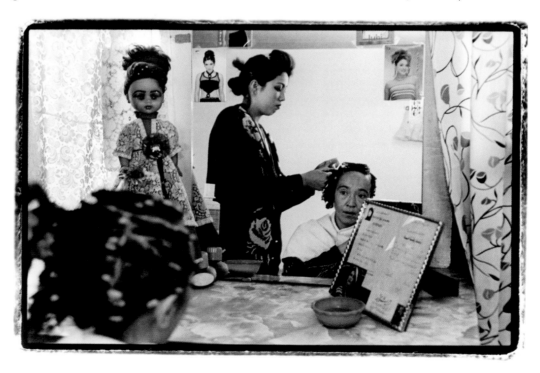

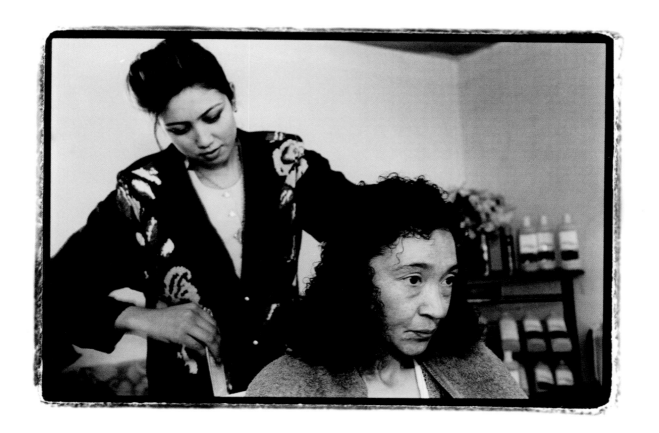

make their hair look like this or that one. Preity [Zinta, an Indian model and actress] is one of their favorites. And especially Kate Winslet in *Titanic*. We like how she looks very much and many women say, "Give me a *Titanic* haircut." People don't know much about these things but they are hungry for influences like that.

Before the Taliban, people didn't copy so much from the outside world. Now imitation is everywhere. Women have spent too long at home with nothing to think about but their appearance. Makeup became a sign of defiance during the Taliban days, and women began to wear much more of it. Before the Taliban came, they had other things to think about, like their jobs.

Now, we can go back to how things were. I think women will wear less makeup again soon. Women come to our salon to get their makeup done, and you wouldn't believe how much they are used to wearing from the Taliban years!

I hope that women in other countries will help us here to carry the message that we deserve our rights. We want pressure put on our government to respect the rights of women. We will fight to gain our rights, but it is hard for us because we have lived for so many years fearing men.

After Ramadan we want to move the shop to the main street. We don't have to stay behind these gates anymore. And we have found a great place to open our new shop.

LAILA

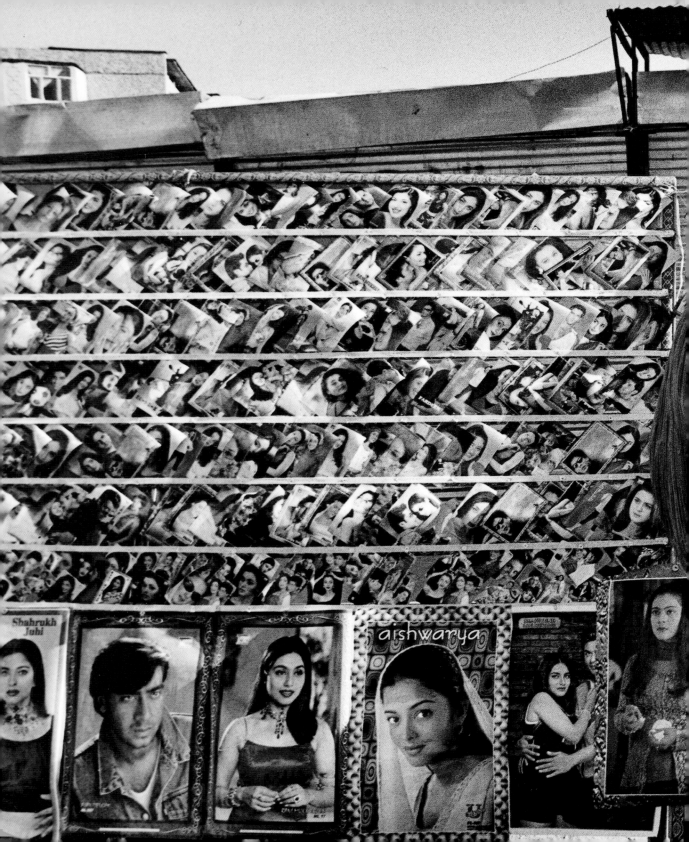

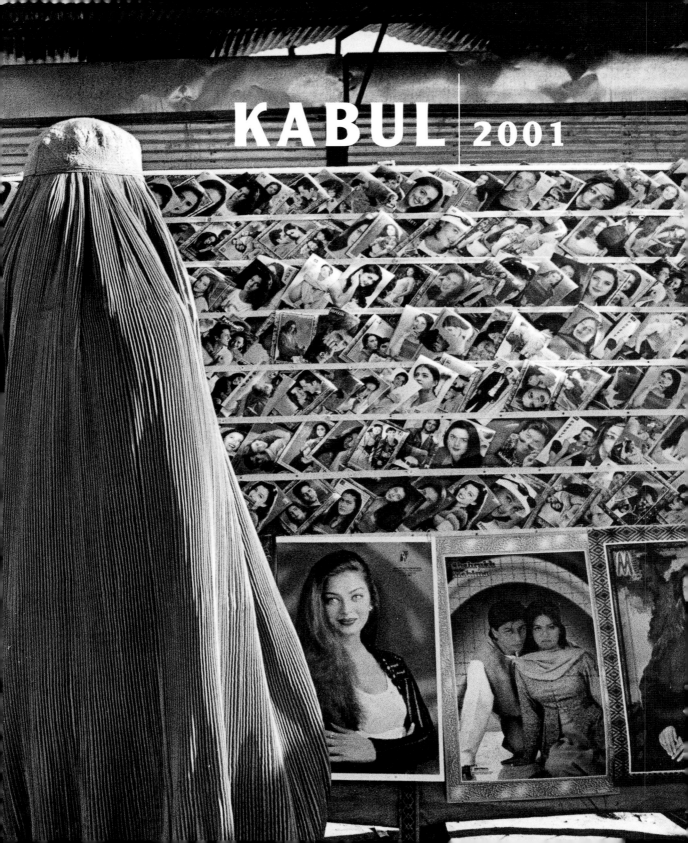

KABUL 2001

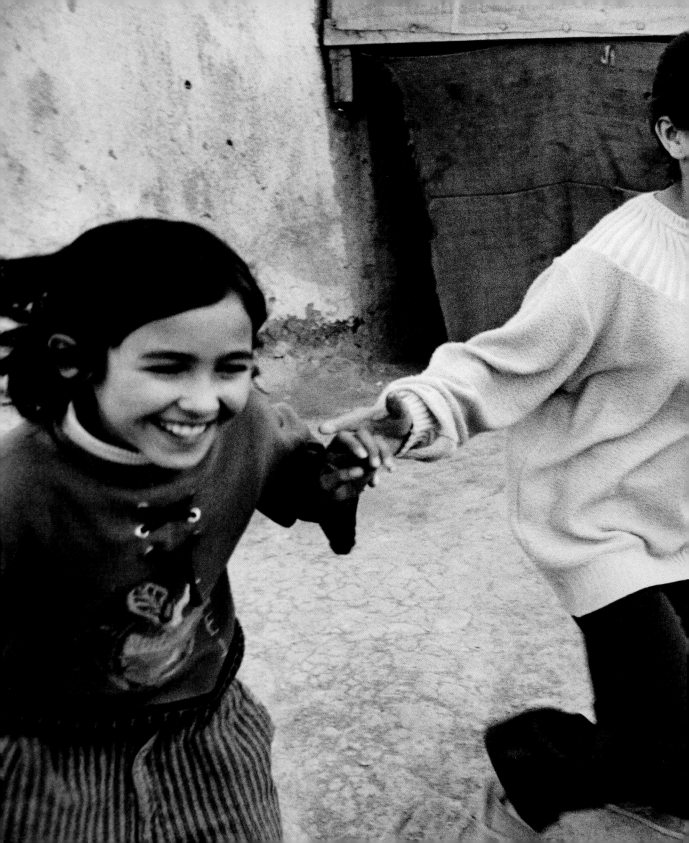

ACKNOWLEDGMENTS

THANK YOU to my mother, Deborah, for looking after my kids when I was away, and for never showing me any fear about what I did. Network Photographers for their support and hard work on my behalf, especially Graham and Sam. To Mary MacMakin and the women at PARSA for their bravery and assistance, and to Aidan Sullivan for sending me there in the first place. To Jenny Matthews, Simon Norfolk, and Nikolai Ignatiev, who made great travel companions. To Roya, my translator, and Fahrid for their intense hours in Kabul. To Engineer Abdul Ghaffar for his security and friendship. To Robin Bell for his hard hours at work and beautiful black-and-white printing all through his Christmas and New Year, and to Jim Silverstone at Outback for his color work. To Sarah Spence for her help in organizing the text. And to ReganBooks for making this happen, especially Aliza Fogelson and Dan Taylor for their editing work.